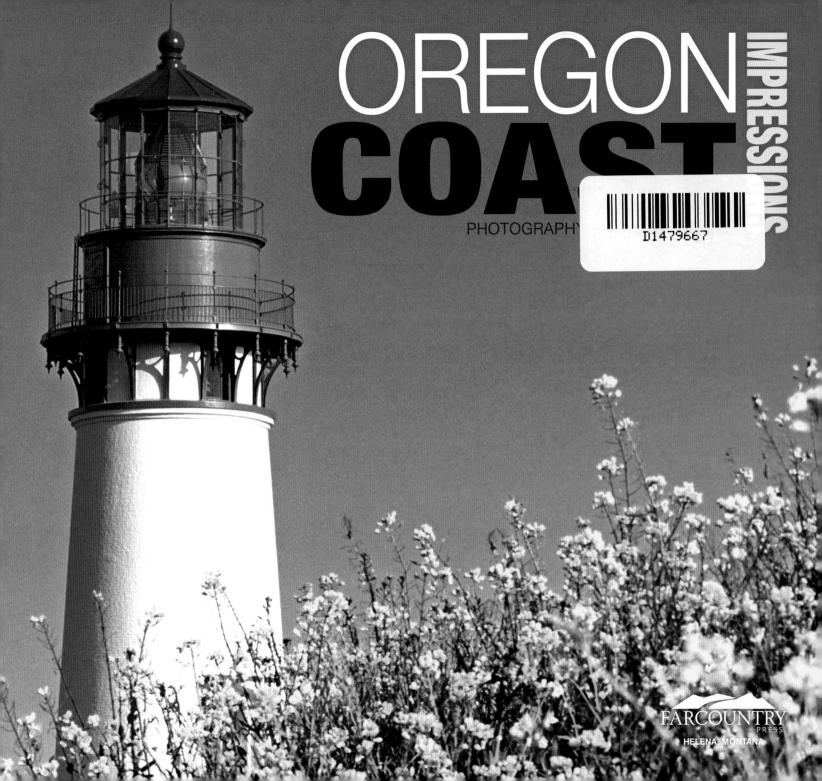

OREGON
COAST
IMPRESSIONS

PHOTOGRAPHY

FARCOUNTRY
PRESS
HELENA, MONTANA

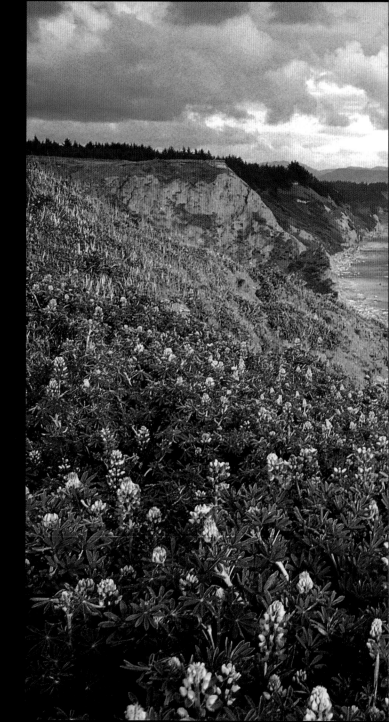

Right: Lupines bloom prolifically above the beach at Cape Blanco State Park, which holds the distinction of having Oregon's southernmost as well as westernmost lighthouse.

Title page: Yaquina Head Lighthouse sends its automated powerful beacon of 1,000 watts in a unique pattern of two seconds on, two off, two on, fourteen off. When it was first lit in 1873, the light was powered by burning oil.

Cover: This misty, magical scene is caused by an offshore wind at Cannon Beach. Haystack Rock, at left, rises 235 feet above the surf.

Back cover: Sunrise immerses the Oregon coast in a soft, colorful glow.

ISBN 10: 1-56037-436-5
ISBN 13: 978-1-56037-436-7

© 2008 by Farcountry Press
Photography © 2008 by Dennis Frates

For more information about our books, write Farcountry Press, P.O. Box 5630, Helena, MT 59604; call (800) 821-3874; or visit www.farcountrypress.com.

Created, produced, and designed in the United States.
Printed in China.

13 12 11 10 09 08 1 2 3 4 5 6

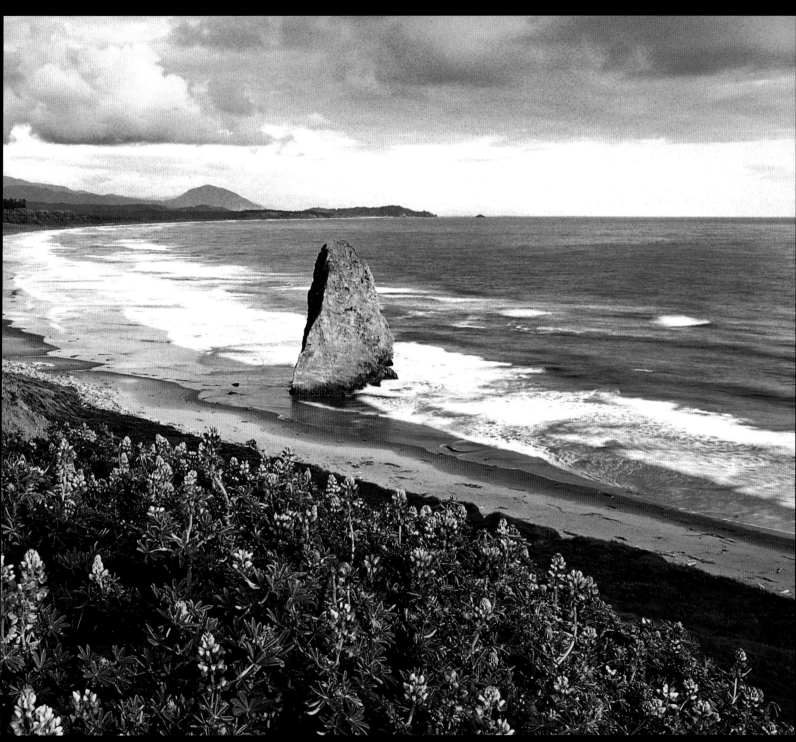

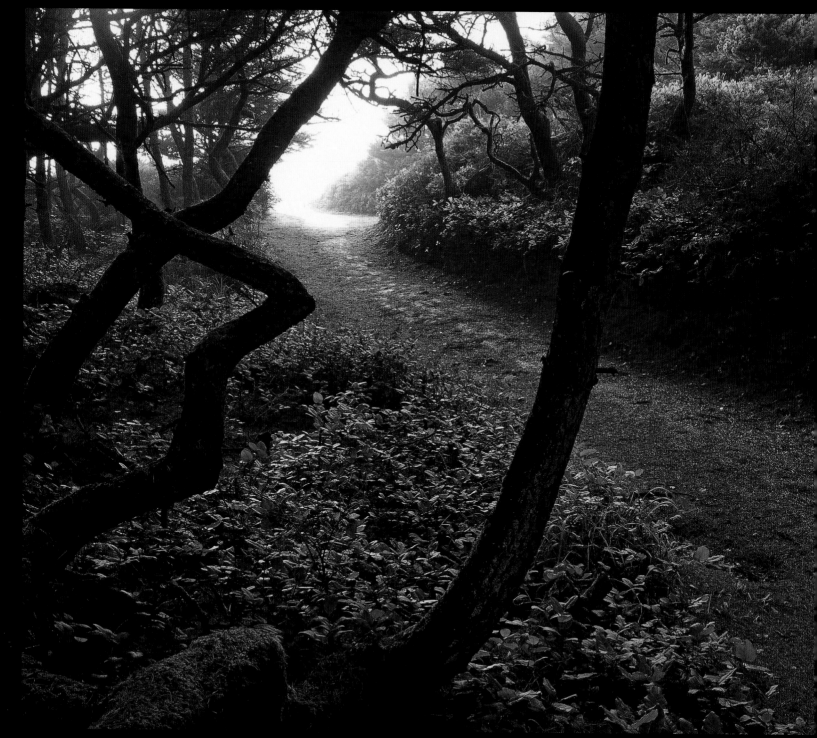

Left: Seal Rock State Park provides access to the coast via soft footpaths through the forest. One trail leads to a pleasant picnic area in a shady stand of shore pines, spruces, and salal.

Below: The wooden-hulled tugboat *Mary D. Hume* steamed into Gold Beach in 1978 and was abandoned, after nearly a century of service.

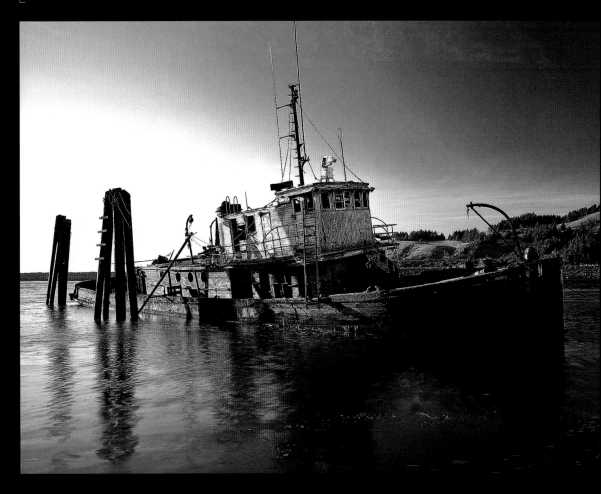

Facing page: The final rays of sunlight bathe the cliffs beyond fifty-six-foot-tall Heceta Head Lighthouse, situated 205 feet above the surf at Devils Elbow State Park. On a clear night, its light can be seen from twenty-one miles out to sea.

Below, left: Low tide reveals the fascinating sea life that flourishes along the coast. These entwined starfish are near Strawberry Hill.

Below, right: What you can't see in tide pools can be examined at the Oregon Coast Aquarium, such as this tiger rockfish finning slowly above strawberry anemones. PHOTO COURTESY OF CINDY HANSON, OREGON COAST AQUARIUM.

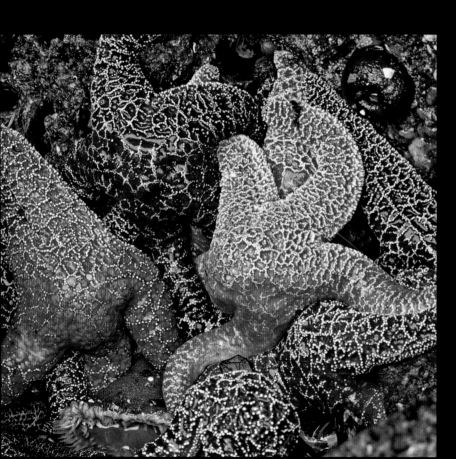

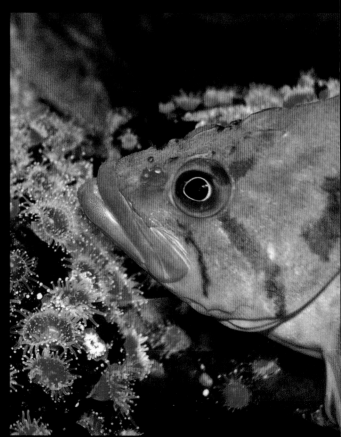

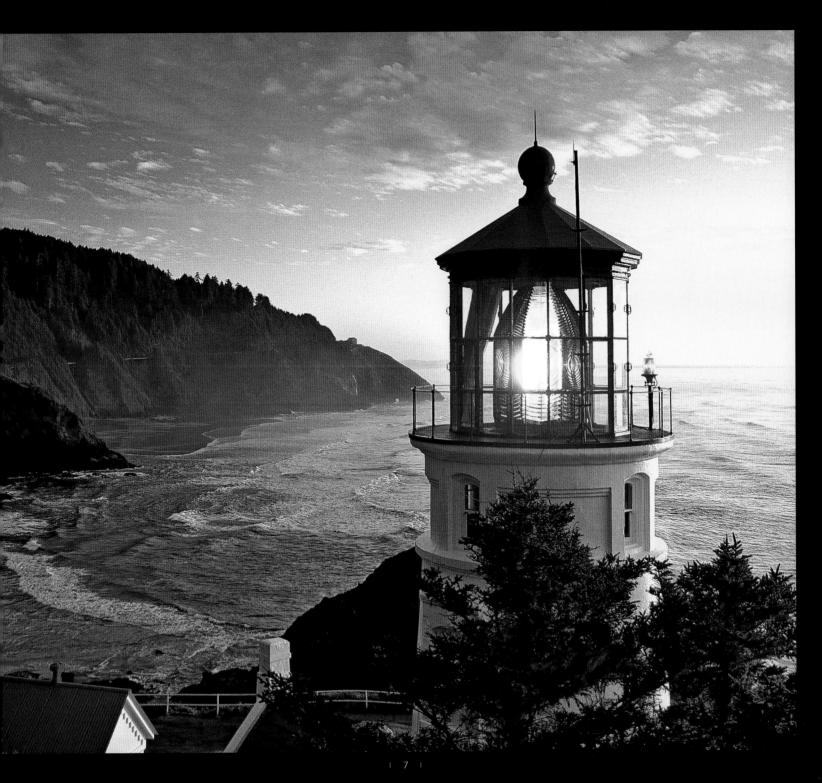

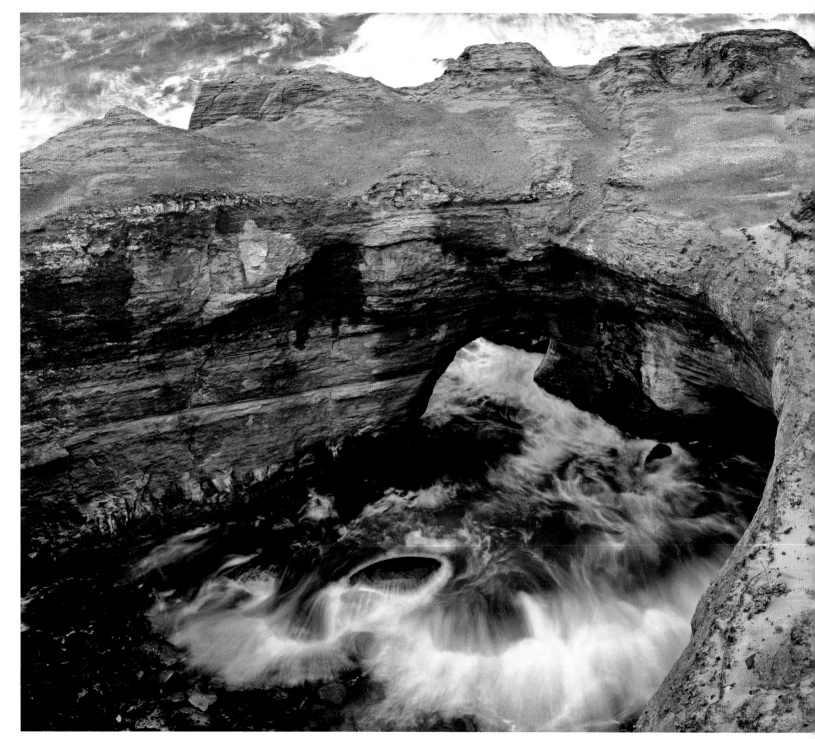

Left: The surging tide swirls into Devil's Punch Bowl, a hollow formation created by the ceaseless erosion of the waves over millennia. Geologists believe this was originally two sea caves; the "bowl" was created when the roofs collapsed.

Below: This cement replica of a burial canoe on Coxcomb Hill near Astoria eternally faces the ocean. It memorializes Comcomly, a Chinook leader who befriended Lewis and Clark and other Euro-Americans who followed. © LYN TOPINKA

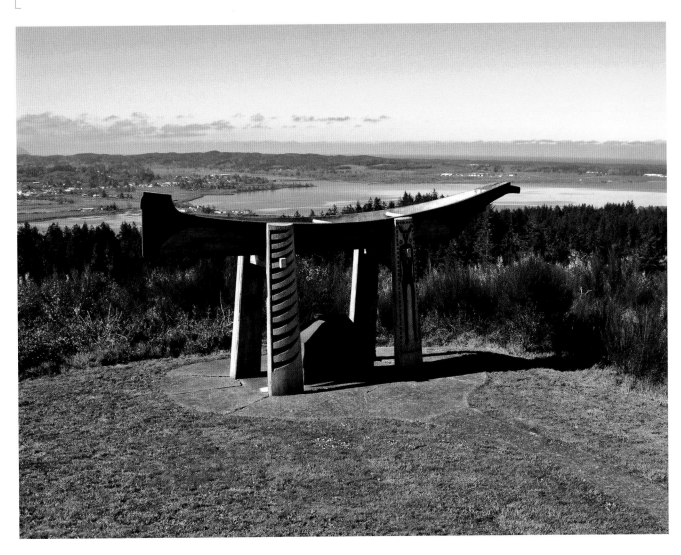

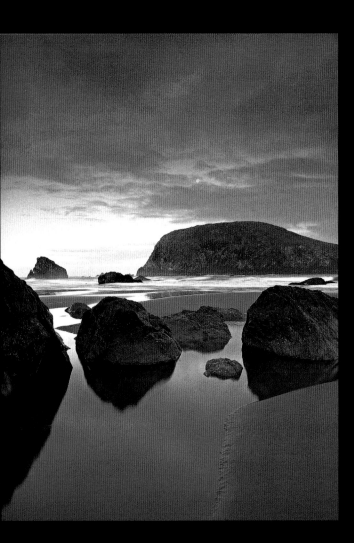

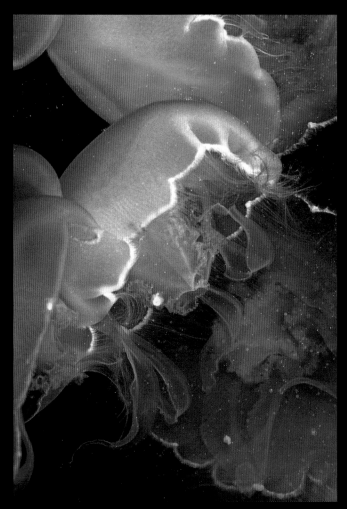

Above, left: The setting moon is barely discernible through the pastel clouds colored by a rising sun at Samuel H. Boardman State Park. This park encompasses twelve linear miles of rugged coast and small beaches, as well as groves of 300-year-old Sitka spruces. The hardy Sitka spruces flourish where the coast's mild temperatures, extreme winds, and dense fog discourage other types of vegetation.

Above, right: Moon jelly, egg yolk jelly, crystal jelly, upside-down jelly, lion's mane jelly. A variety of jellyfish are on view at the Oregon Coast Aquarium in Newport.

Right: As the world turns … the sun appears to sink into the ocean.

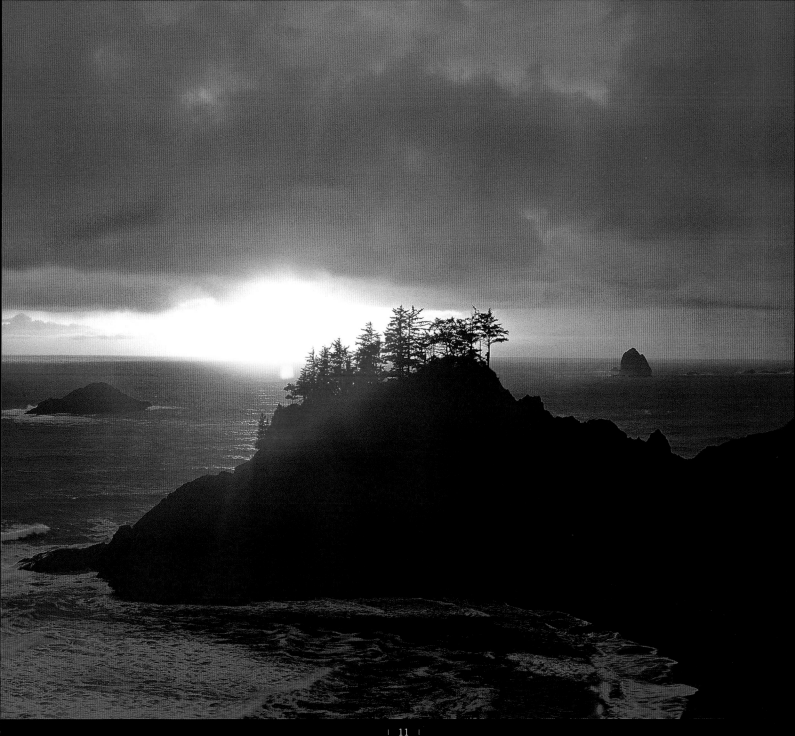

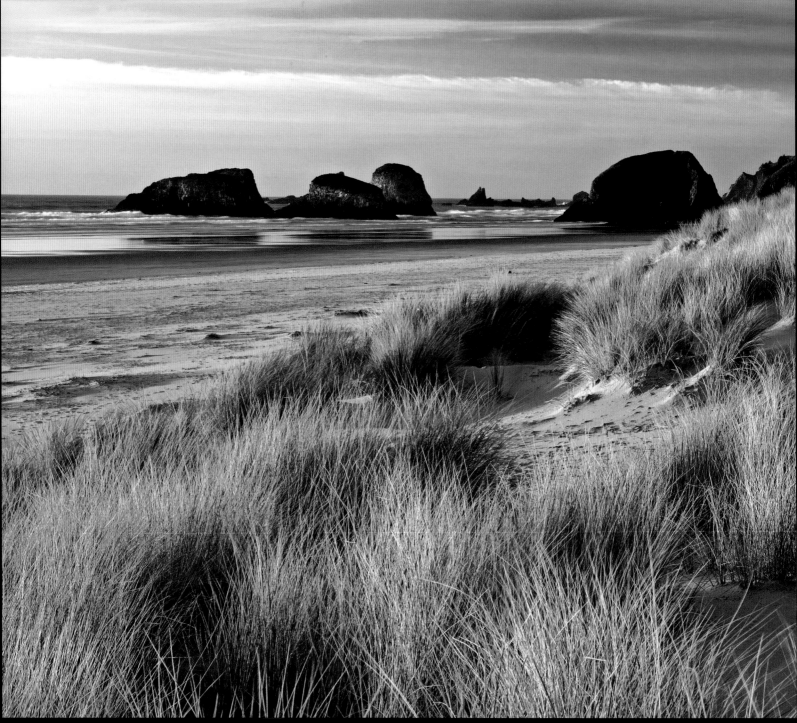

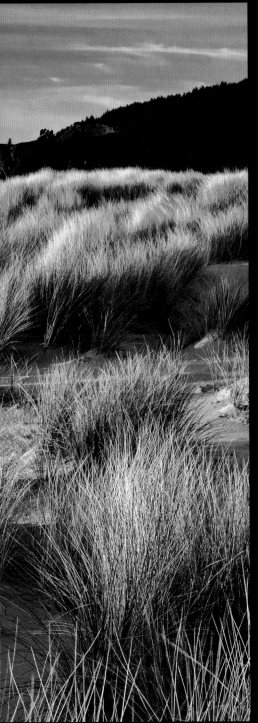

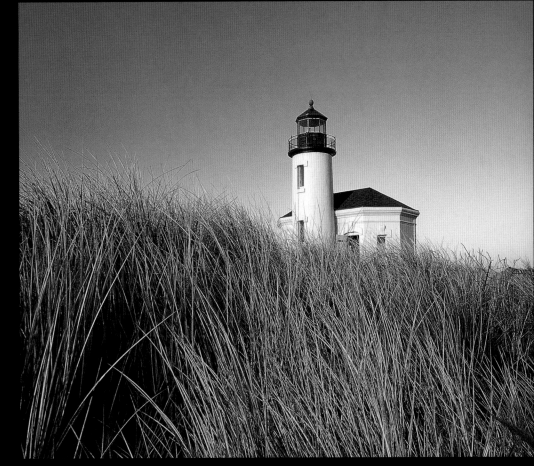

Above: Dune grass flourishes in the sand surrounding Coquille River Lighthouse. Built in 1896 on Rackleff Rock, it acted as both a coastal and a harbor light until 1939, then was abandoned. It is now restored and open to the public as part of Bullards Beach State Park.

Left: Sea stacks are remnants of former headlands or cliffs that resisted erosion. These scattered, very dense rock formations characterize much of the Oregon coast, seen here at Cannon Beach.

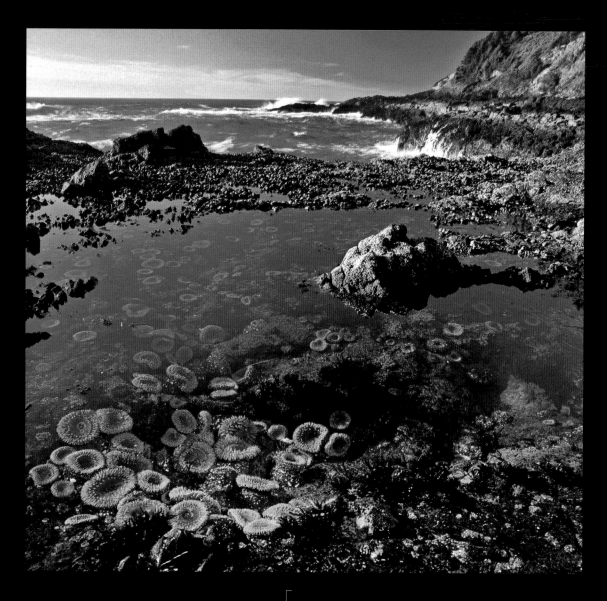

Above: Sea anemones are revealed in a tidal pool at Cape Perpetua. Capt. James Cook named the cape in 1778 for Saint Perpetua; today's visitors reach the pools at low tide via the Captain Cook Trail.

Right: Only scuba diving could get you any closer to life under the sea. The Oregon Coast Aquarium's "Passages of the Deep" exhibit safely brings you face to face with creatures such as sharks and bat rays.

PHOTO COURTESY OF CINDY HANSON, OREGON COAST AQUARIUM.

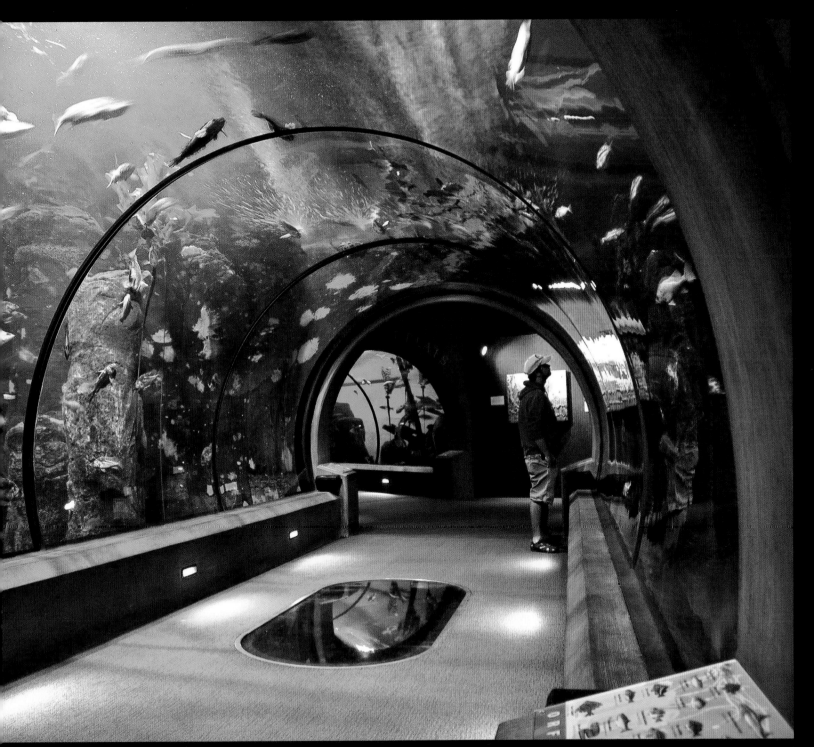

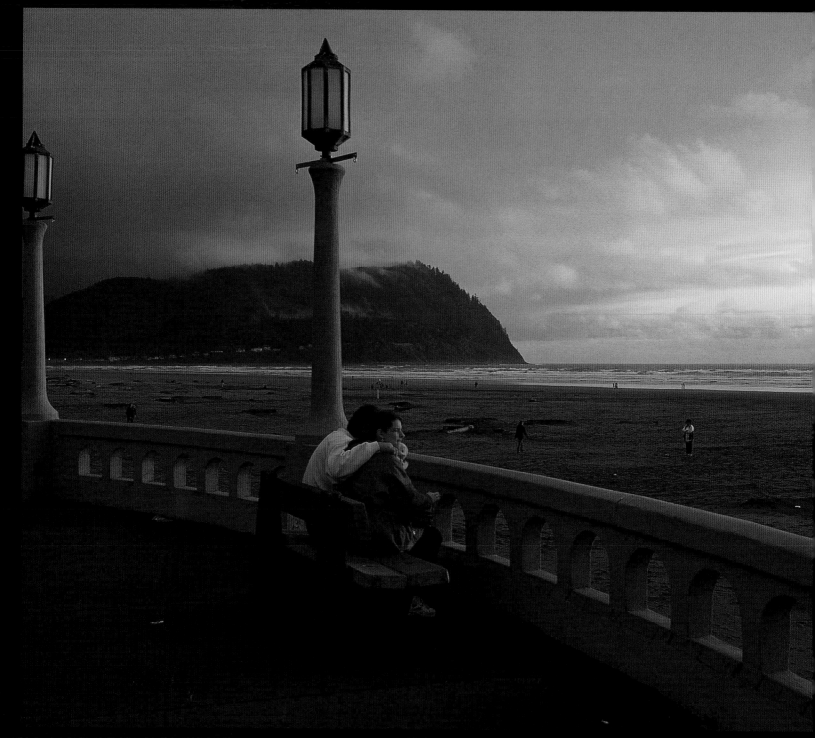

Left: Sunset at Seaside Beach provides all the romance any couple could wish for.

Below: Haystack Rock, off Cape Kiwanda, is a seasonal home to wildlife such as tufted puffins, cormorants, and gulls. The rock monolith, rich with marine life on and around it, has been designated a National Wildlife Refuge and Marine Garden.

Following pages: Cape Sebastian provides a splendid view south that extends nearly fifty miles. In 1603, Spanish navigator Sebastian Vizcaino named the cape for Saint Sebastian.

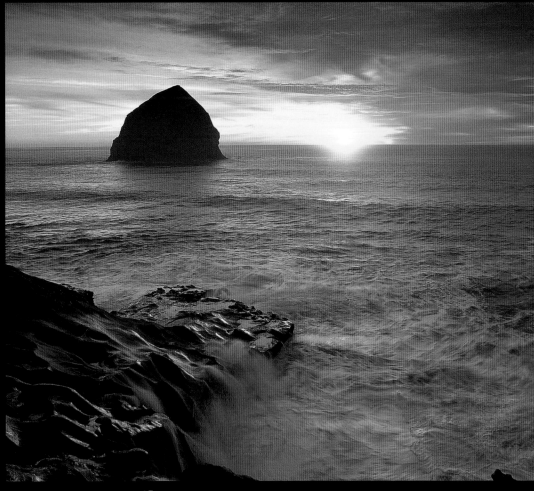

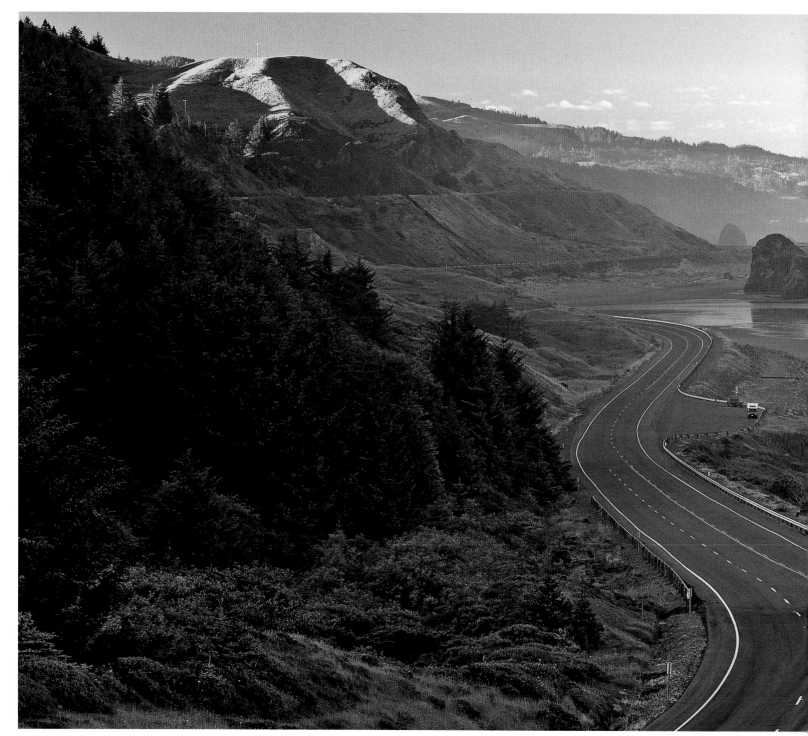

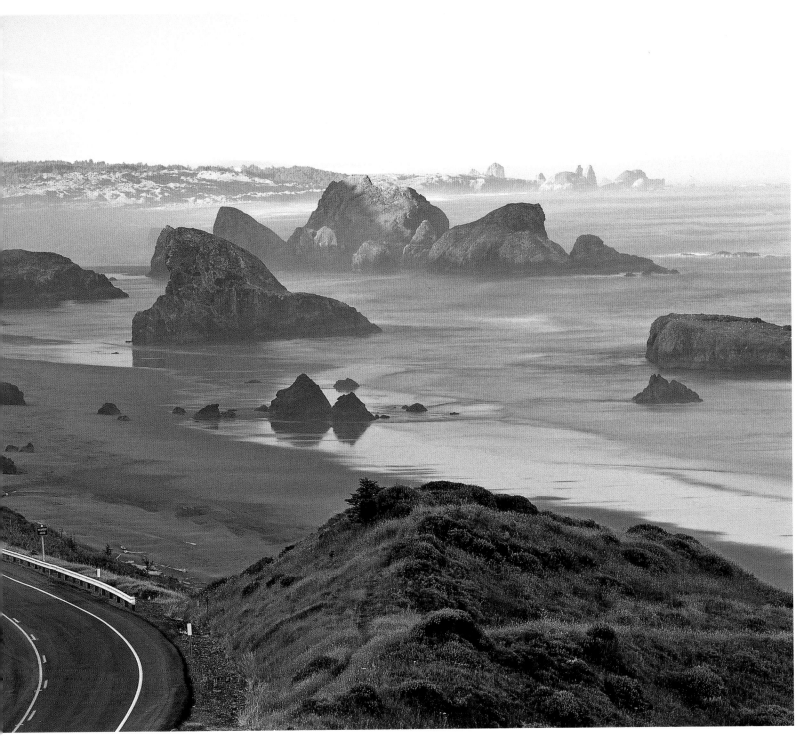

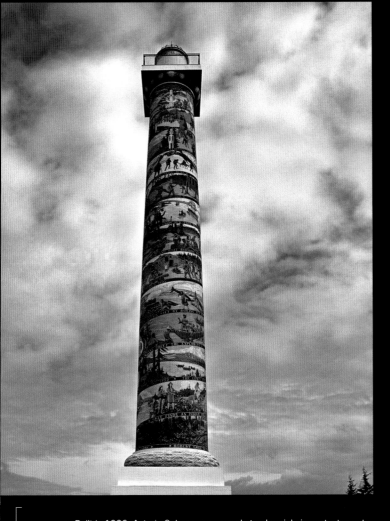

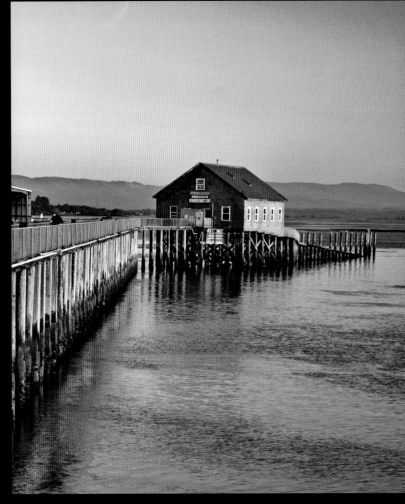

Above, left: Built in 1926, Astoria Column uses murals to chronicle important events in the area's fairly recent history, from the native people's habitation to the short visit by the Lewis and Clark Expedition to the arrival of the first permanent Euro-American settlers in this region. Today's visitors can climb 164 steps inside the 125-foot tower to reach a platform with spectacular views.

Above, right: The wooden pier at Garibaldi draws people who love to stroll above the sea.

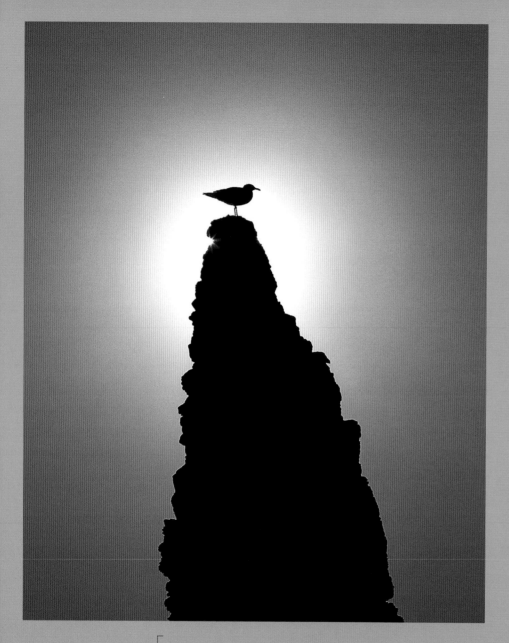

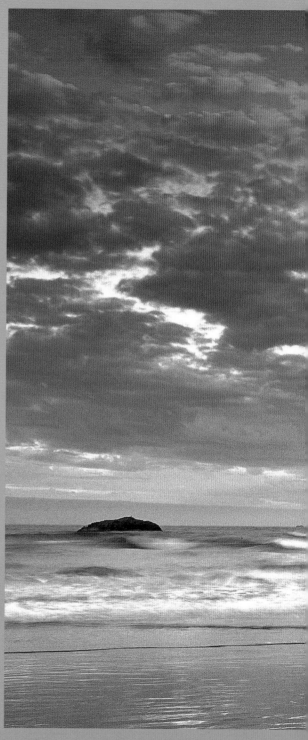

Above: A seagull finds a safe perch atop one of the innumerable sea stacks that give the Oregon coast such a distinctive look.

Right: Early morning rays have just reached the tops of the volcanic rocks that shelter Bandon Beach, seen here in the calm, reflective waters of low tide.

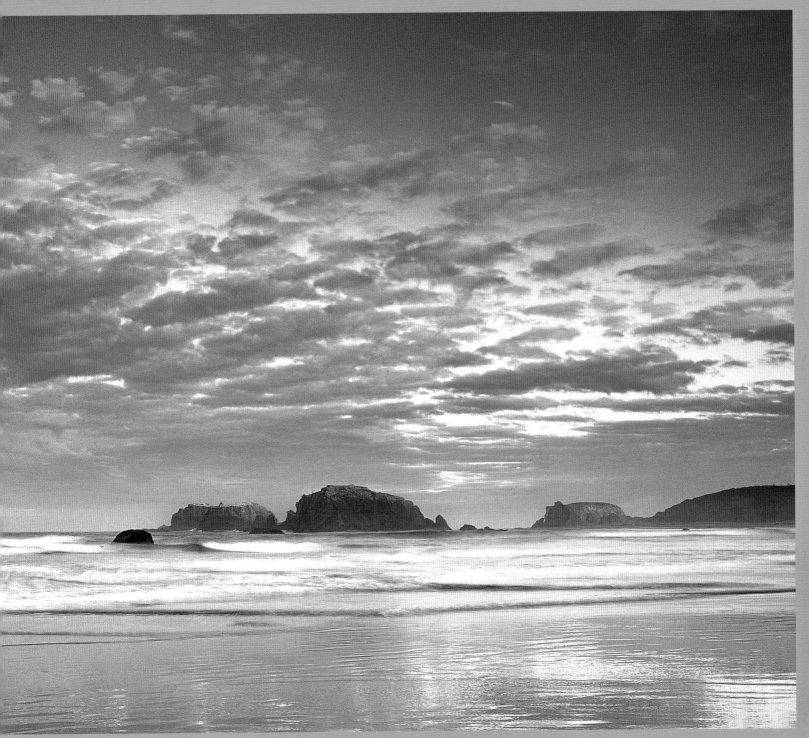

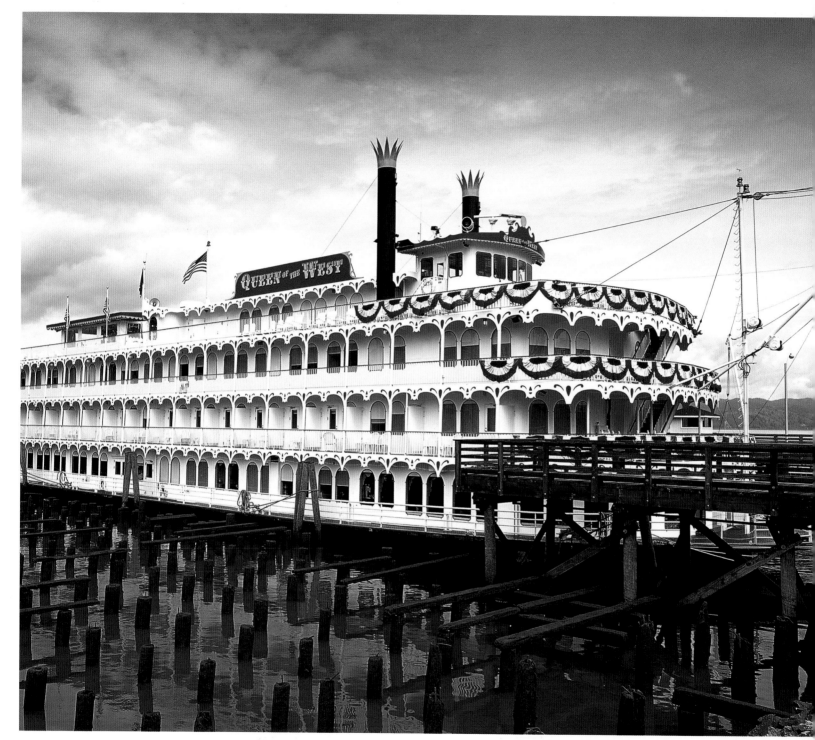

Facing page: The *Queen of the West* awaits her passengers. This plush, authentic, elegant sternwheel paddleboat plys the Columbia River on one-week cruises from Portland, with numerous side trips to area attractions.

Below, left: The U.S. Coast Guard barracks are shipshape at Tillamook Bay Station.

Below, right: Heceta House, built in 1893, formerly housed the assistant lighthouse keeper for the nearby Heceta Head Lighthouse. Today a part of Devils Elbow State Park, it is available for group events and serves as a bed and breakfast.

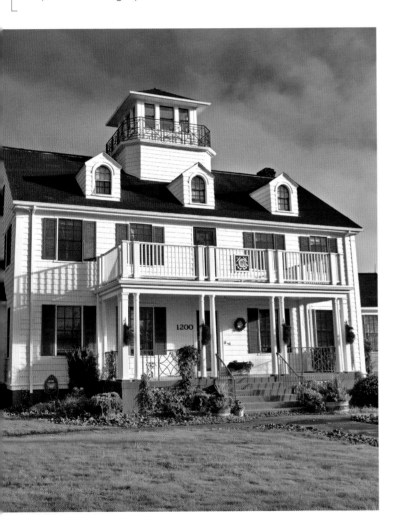

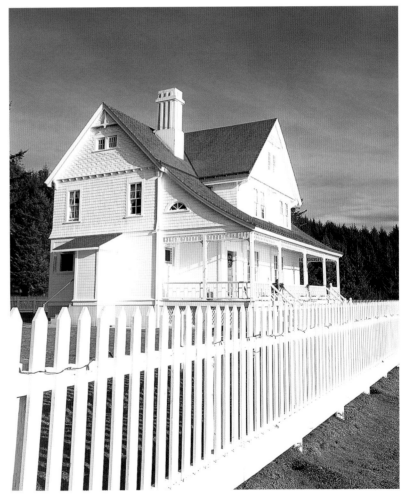

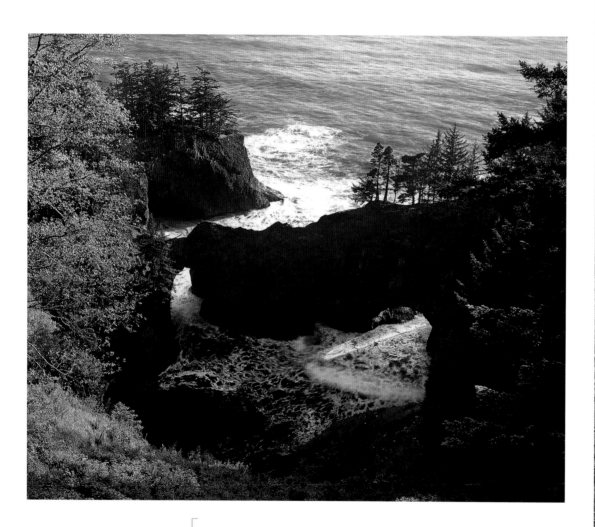

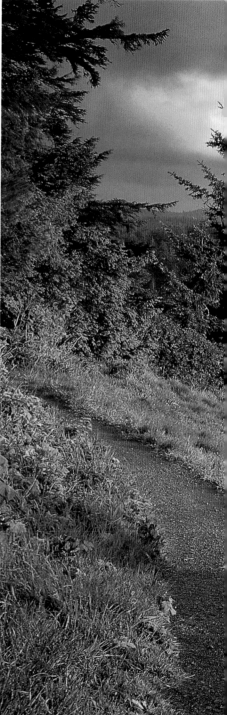

Above: The natural bridge preserved in Samuel H. Boardman State Park was created by the never-ending pounding of waves slowly eroding a softer spot in the cliffs.

Right: Cape Perpetua Scenic Area provides twenty-six miles of interconnected hiking trails that lead through magnificent forests in the Coast Range as well as along the coast.

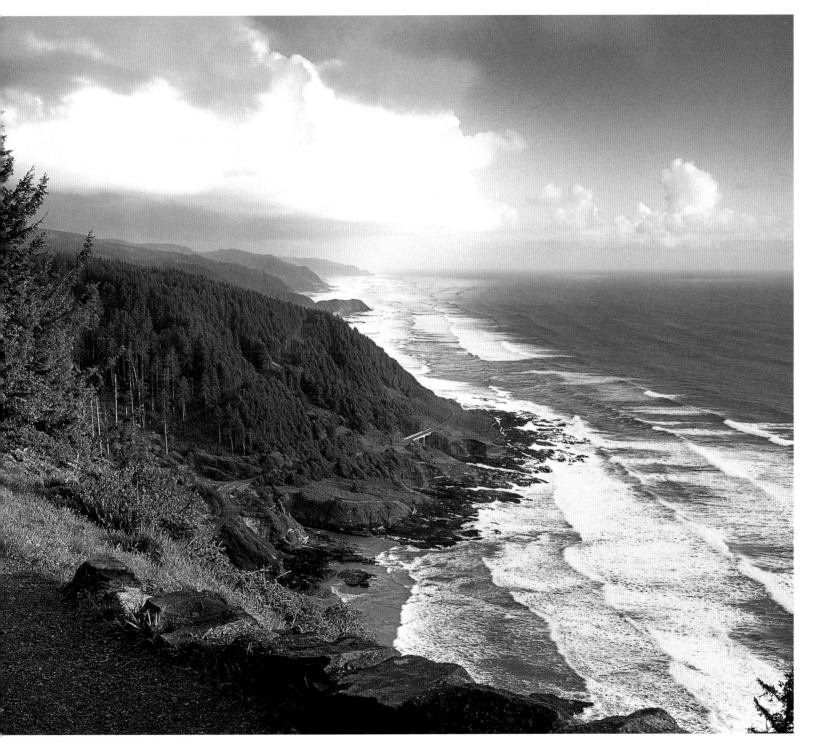

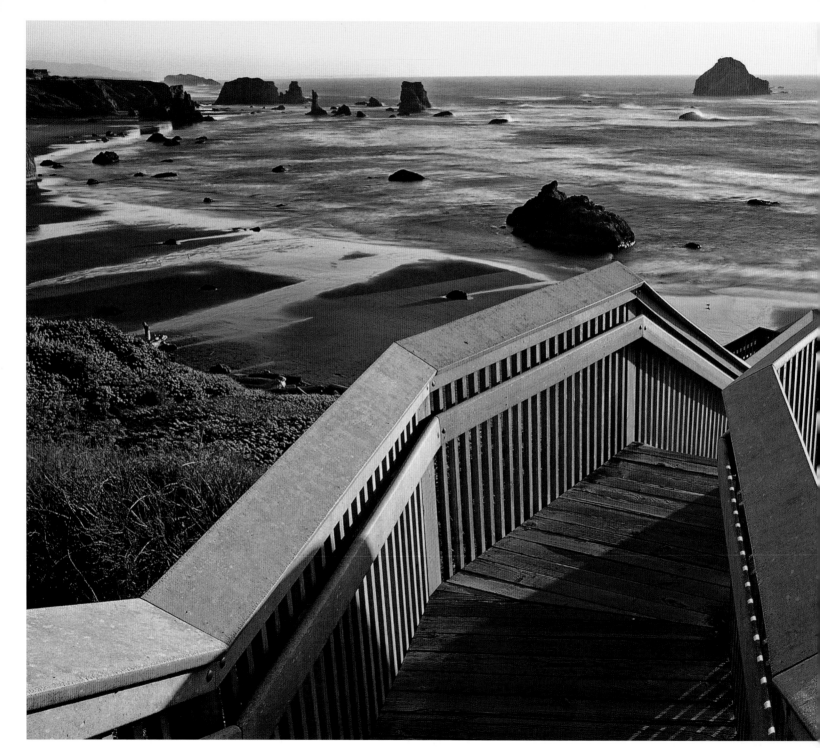

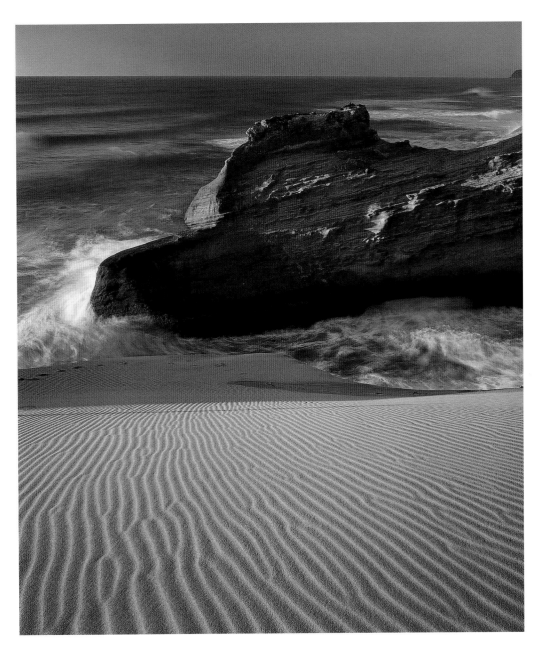

Above: Striations in the sand dunes reveal the predominant wind direction hitting Cape Kiwanda. Kiwanda is the smallest cape along the Three Capes Scenic Route, but its waves pack the biggest wallop.

Left: Who could resist descending these artfully crafted stairs to access the great beachcombing on Bandon Beach?

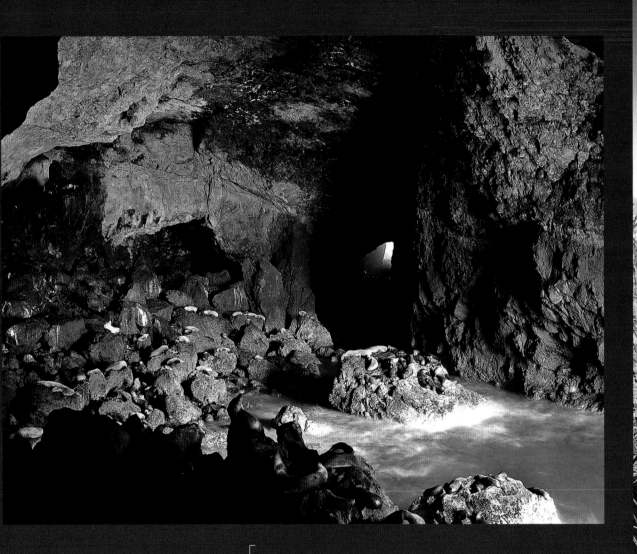

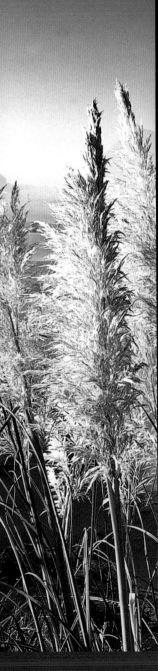

Above: Tawny-furred California sea lions sprawl in wintry sunshine warming a sheltered cove at Sea Lion Caves. They dive to find bottom fish, including skate, small sharks, squid, and rockfish. Steller, or northern, sea lions also inhabit the caves.

Right: Walk through a forest of impressive Sitka spruce for just a mile and a half, and you'll reach the pampas grass swaying at the edge of the beach on Cape Sebastian.

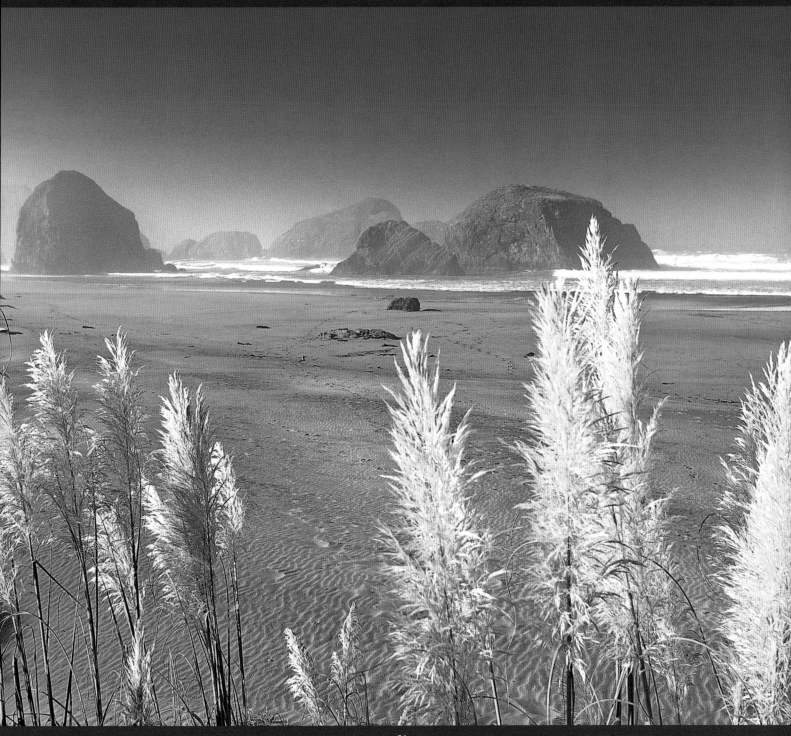

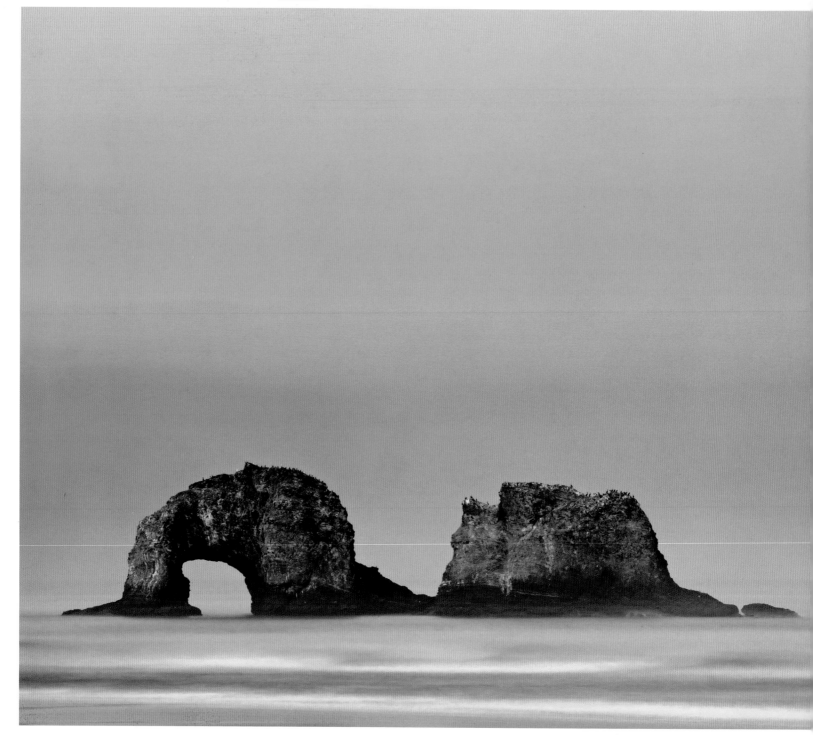

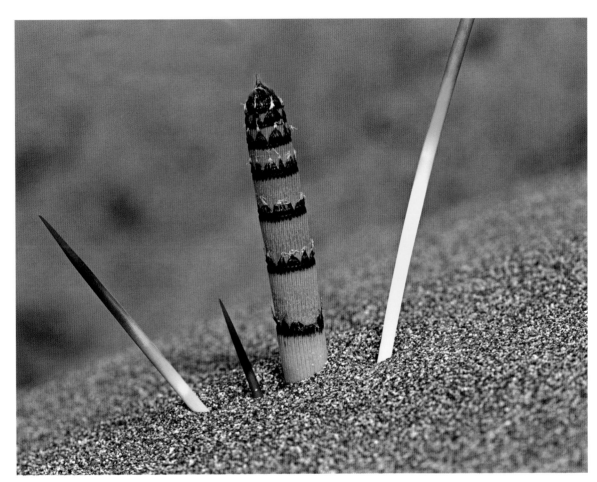

Above: The jointed stalk of *Equisetum*, or horsetail, emerges from a sand dune near Port Orford. Horsetails are one of the most ancient plant genuses, and the plant has changed very little since before the age of dinosaurs.

Left: Arch Rock is one of the most distinctive formations at Rockaway Beach. Photographers have documented it for more than a century; historical photos provide a fascinating look at how wind and wave erosion are wearing it away.

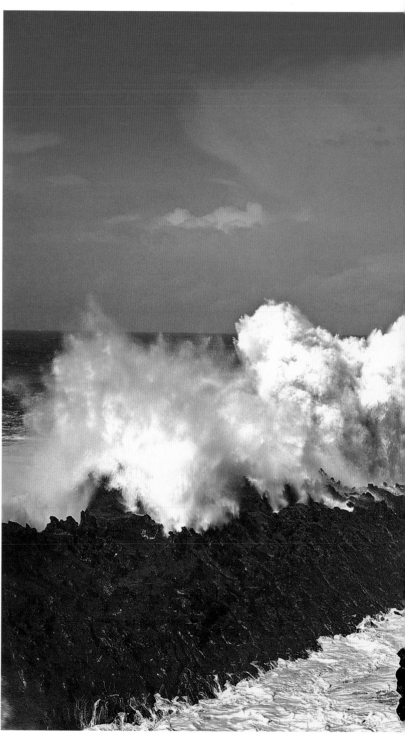

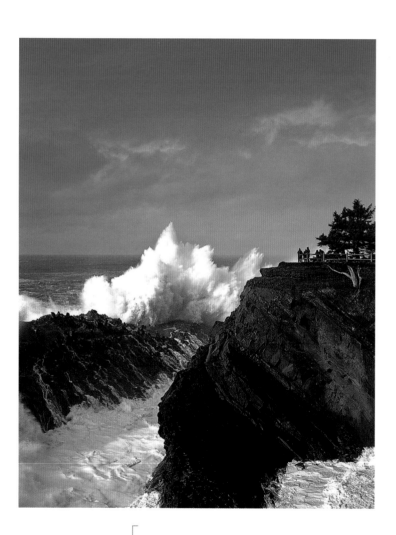

Shore Acres State Park provides a viewing platform that offers an unequalled view of crashing waves driven into the rocks by an oncoming storm.

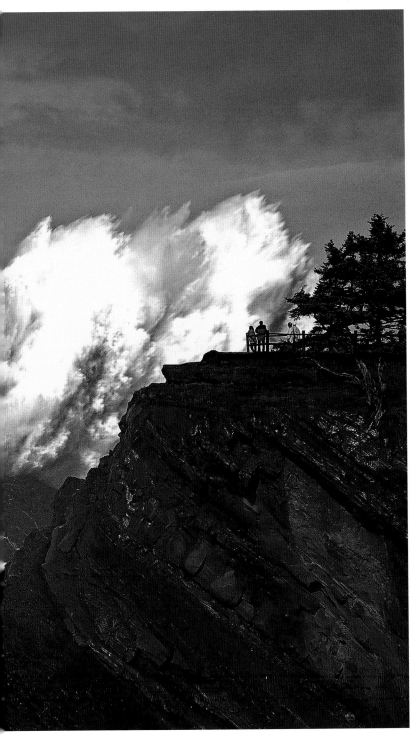
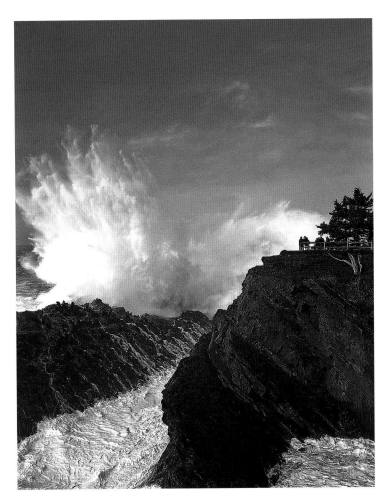

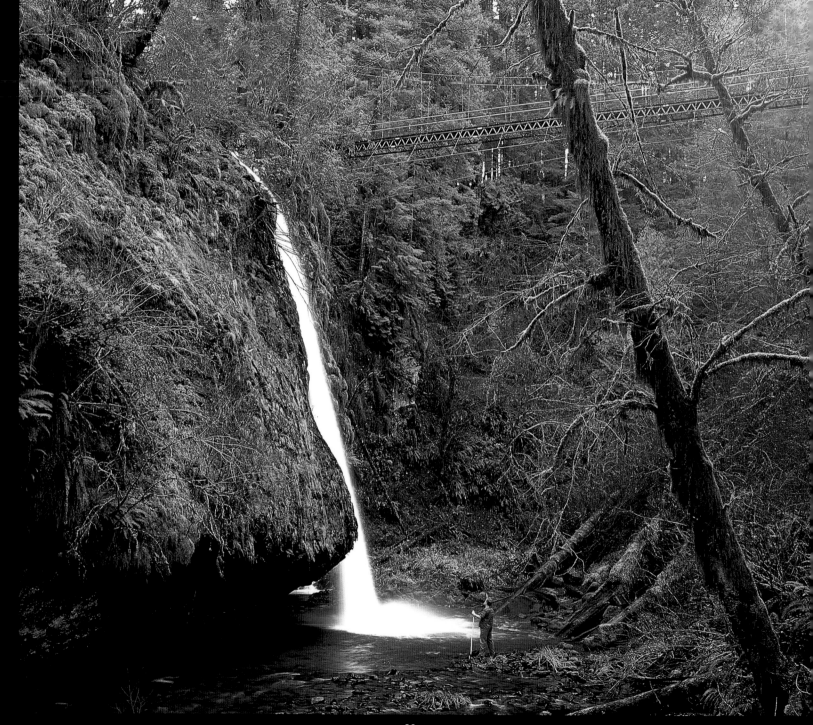

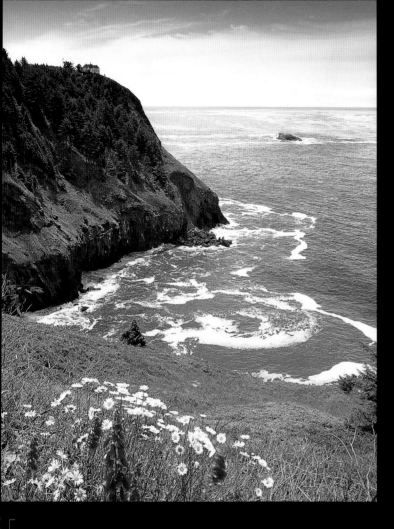

Above, left: The basement rocks in the Coast Range were formed by a volcanic island chain colliding with North America about 50 million years ago. These ancient volcanoes form many of the scenic headlands along the coast.

Above, right: Abundant greenery follows abundant moisture. The Pacific maritime region of the Coast Range receives up to 100 inches of rainfall per year in some areas.

Facing page: Drift Creek Falls drops seventy-five feet, especially spectacular during the spring and fall rainy seasons. Hikers here in the Siuslaw National Forest must cross the 100-foot-high suspension bridge to get across the gorge.

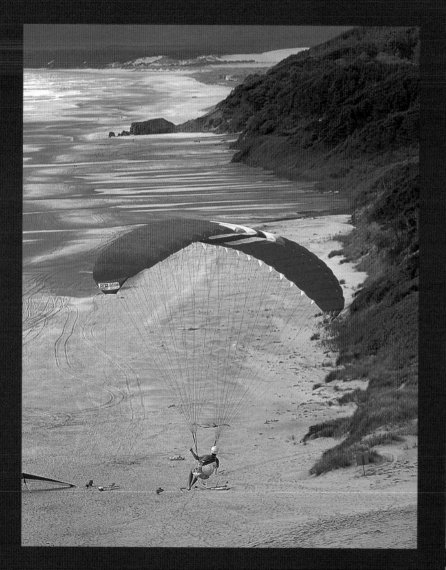

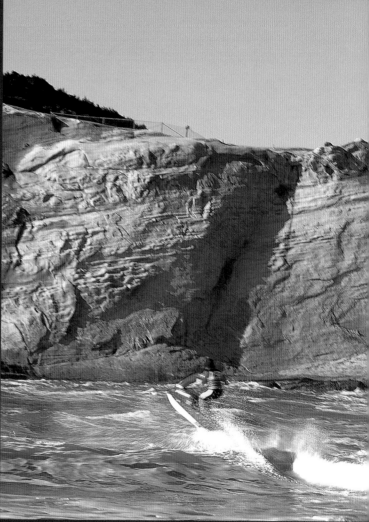

Above, left: Paragliding above it all is popular at the sandy beach north of Cape Kiwanda.

Above, right: Another kind of thrill: jumping waves at Cape Kiwanda.

Facing page: The 1871 Yaquina Bay Lighthouse, listed on the National Register of Historic Places, may be the oldest structure in Newport. Restored and officially relighted in 1996, it is the only functioning wooden lighthouse in Oregon.

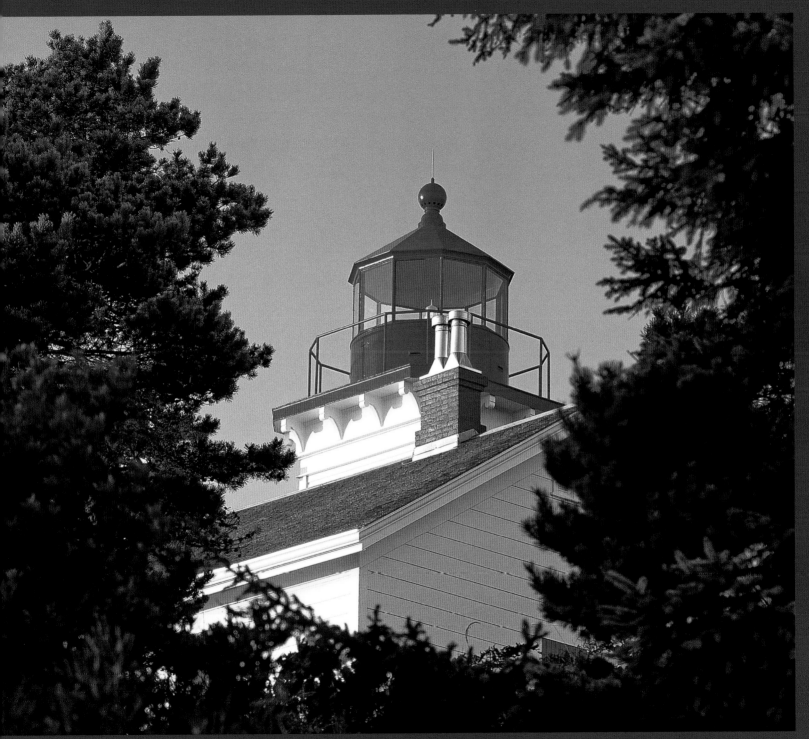

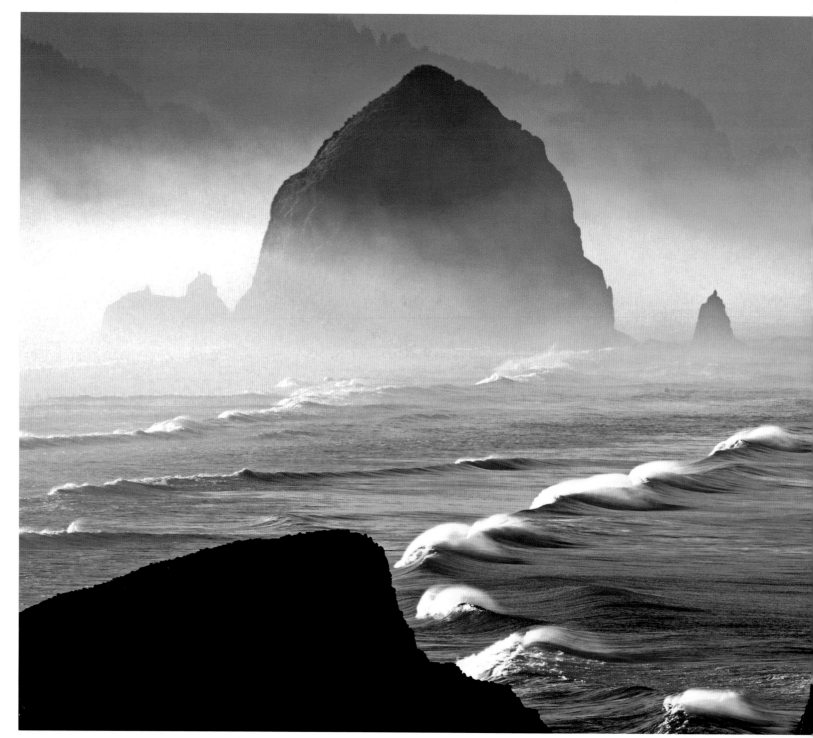

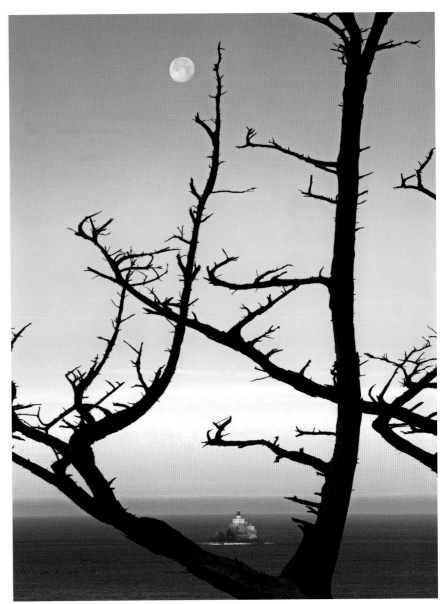

Above: Constructing Tillamook Rock Lighthouse required 525 days of strenuous, dangerous labor. The crew had to climb onto the island via a "breeches buoy" line that often immersed them in icy sea water as the transport cutter pitched and yawed in the swells. One storm in 1880 that pounded the rock for weeks swept away their tools, water tank, and provisions.

Left: An offshore breeze picks up spray from the waves at Cannon Beach.

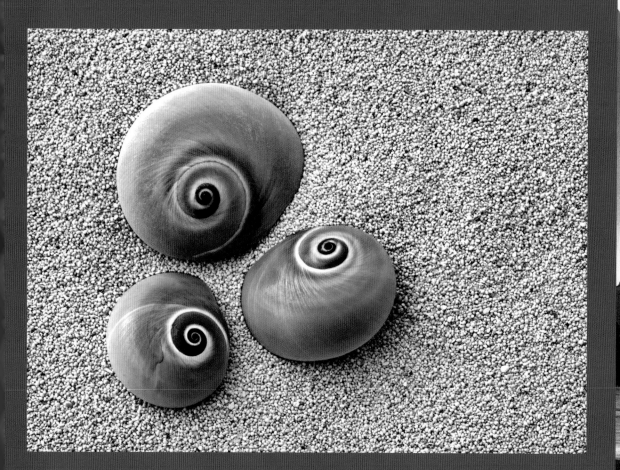

Above: Unblemished snail seashells await a sharp-eyed beachcomber.

Right: A light fog makes an early stroll along the beach at Port Orford a mystical moment. The U.S. Coast Guard operated the Port Orford Lifeboat Station from 1934 to 1970. A museum on nearby Port Orford Heads chronicles Coast Guard history in the region and displays the unsinkable, self-righting wooden lifeboats they used.

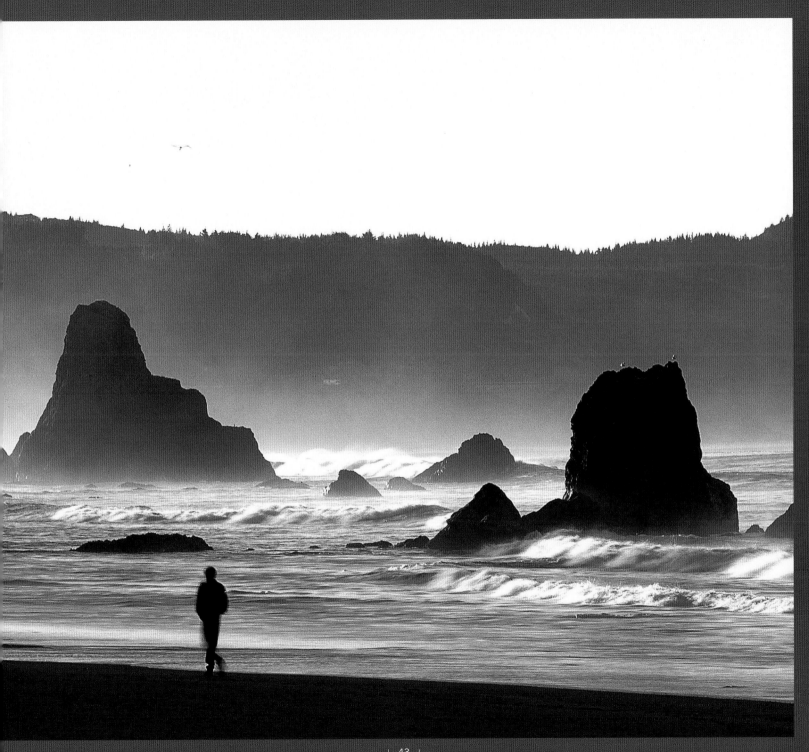

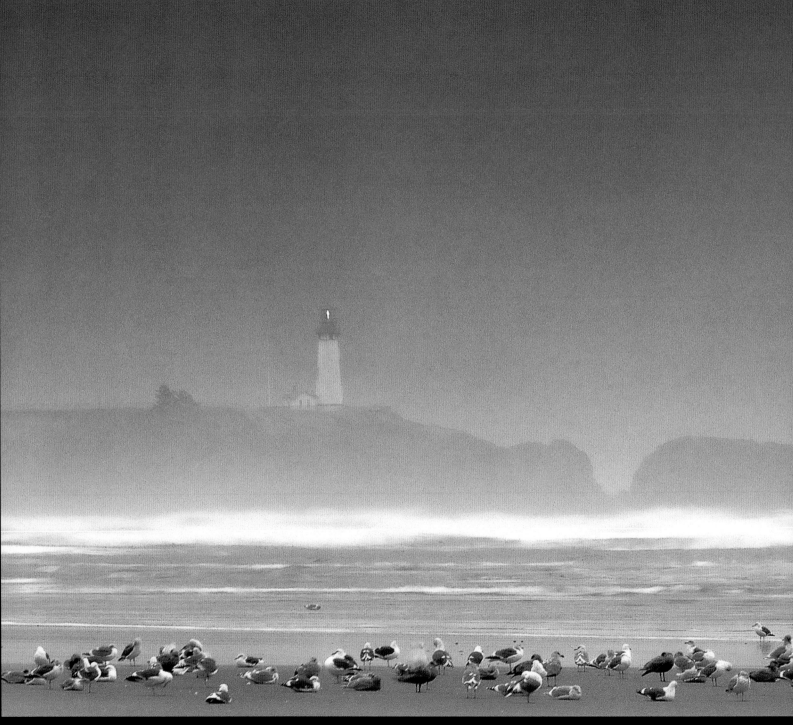

Above: Douglas-fir trees in the Coast Range grow abundantly east of the fog belt, which is dominated by Sitka spruce. A venerable 329-foot-high Douglas-fir grows in Coos Bay. Oregon named the Douglas-fir its state tree in 1939.

Left: Yaquina Head Lighthouse sends its warning beacon through the fog. The ninety-three-foot stucco-covered brick tower is Oregon's tallest lighthouse.

Facing page: Low tide exposes fascinating tide pools at Seal Rock State Park, where you could spend many happy hours learning firsthand about underwater life.

Below, left: Wildflowers flourish above the pounding surf near Whale Cove.

Below, right: Smelt Sands State Park is named for the annual smelt run that occurs nearby. A short, easy footpath brings you to tidal pools and clear ocean views that offer a chance to see some of the 18,000 gray whales that migrate along the Oregon coast.

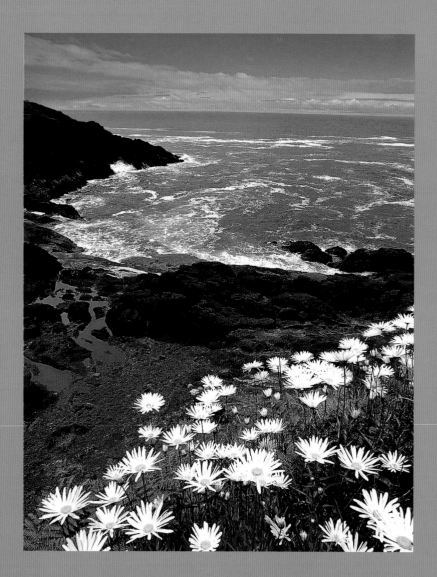

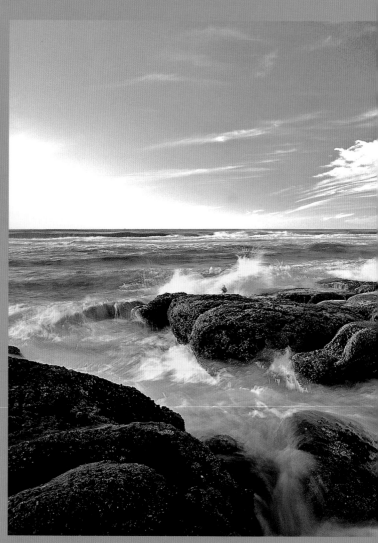

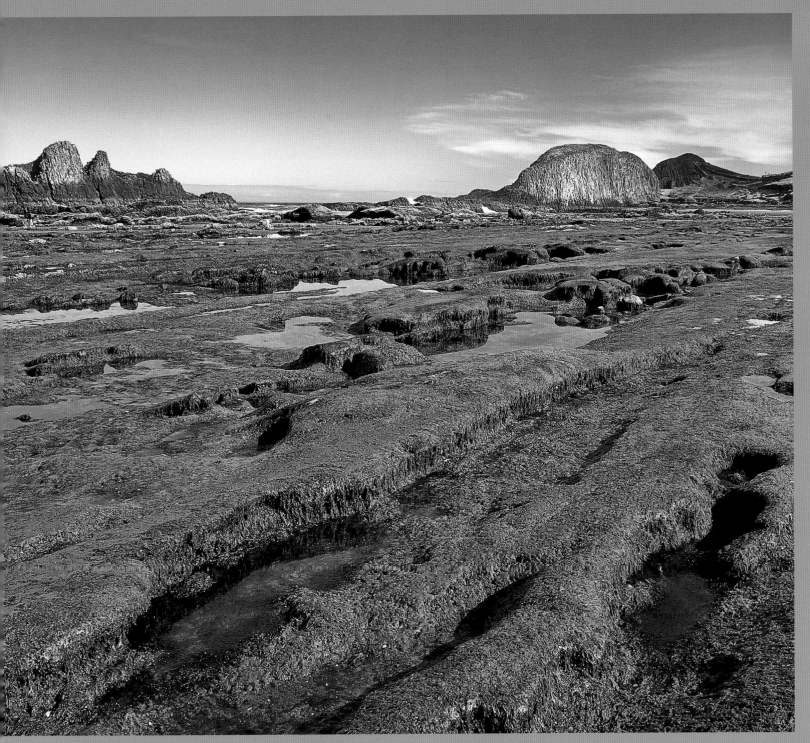

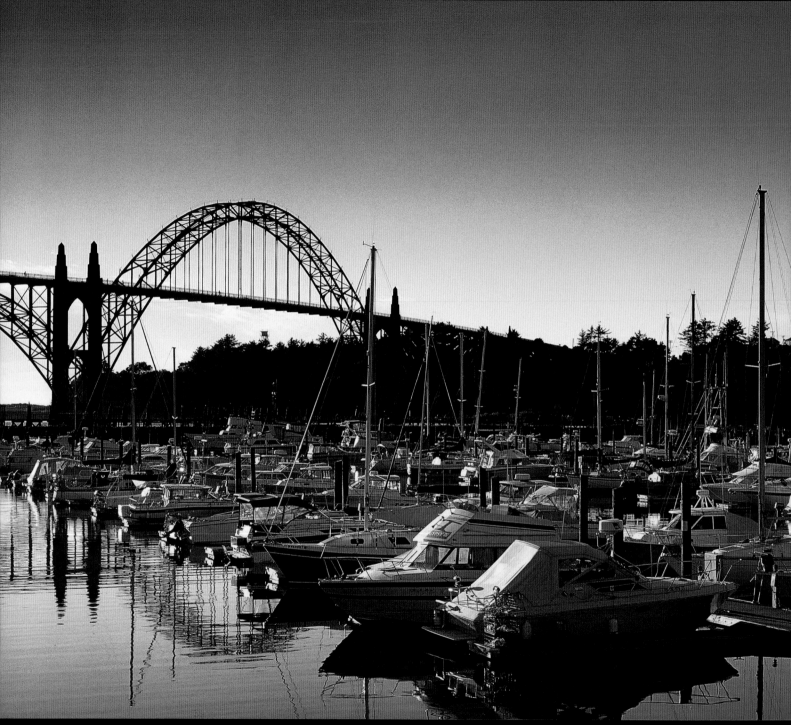

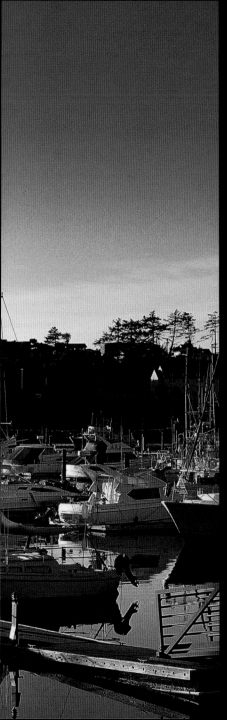

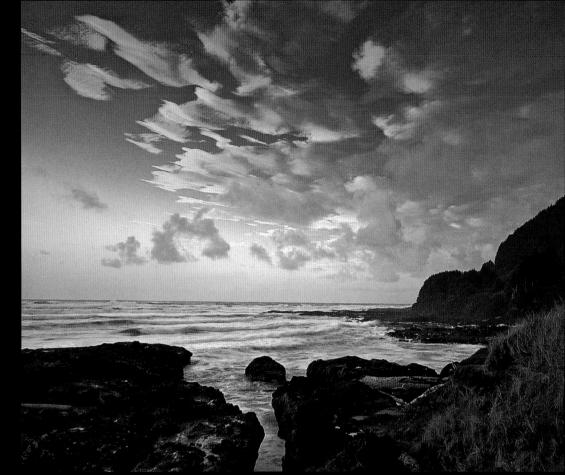

Above: Sunset paints the clouds above the beach near Yachats, pronounced *YAH-hots*, a Chinook Indian word that means "dark water at the foot of the mountains."

Left: Newport was built around Yaquina Bay, which in the 1860s had abundant oyster beds. Residents exported the delicacy to large cities along the coast. Today the bay shelters Oregon's largest commercial fishing fleet, as well as many recreational vessels.

Following pages: Highway 101 provides pullouts for safe viewing of awesome, beautiful stretches of coastline, such as this area just north of Florence.

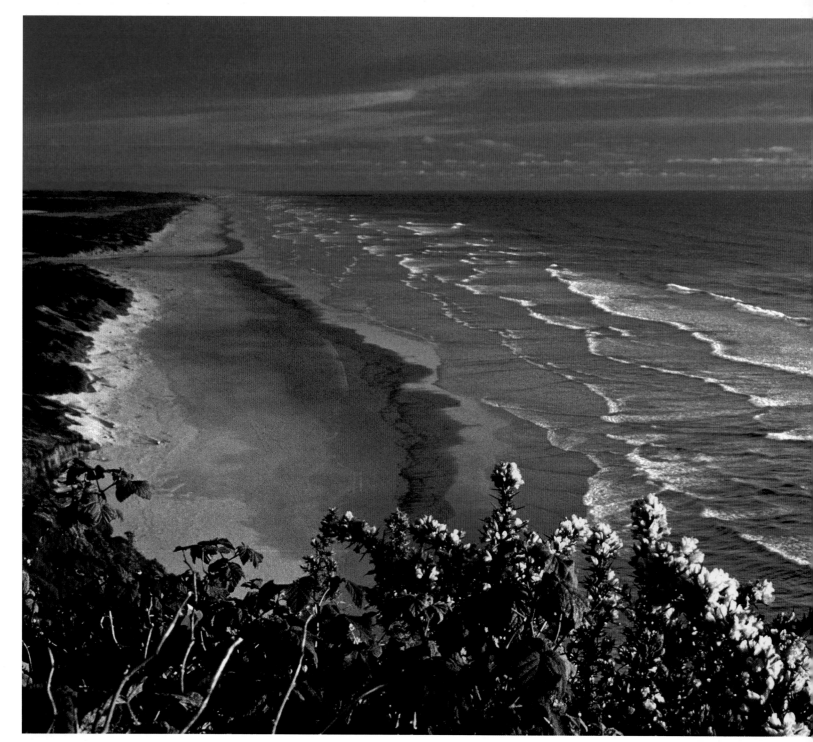

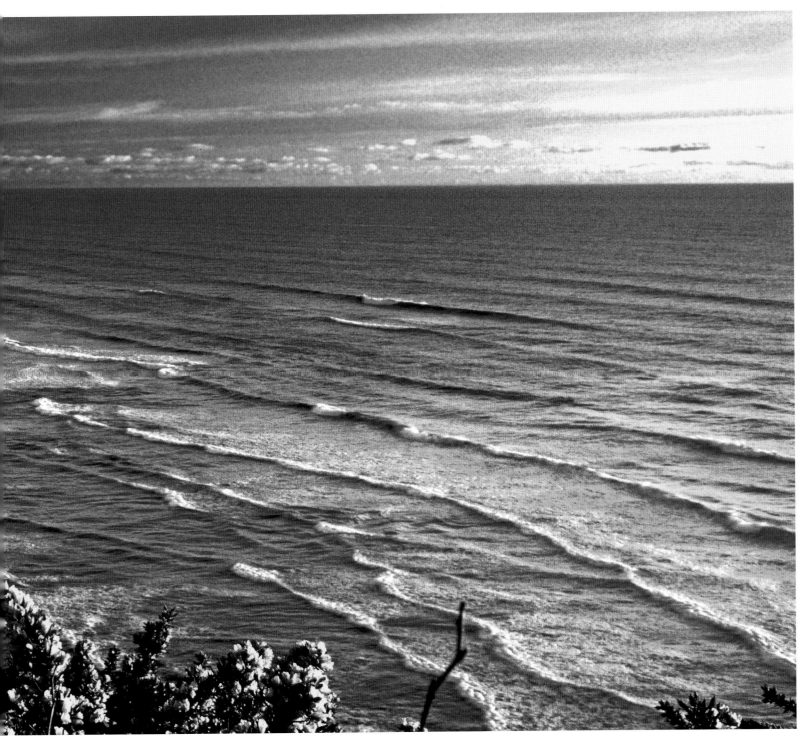

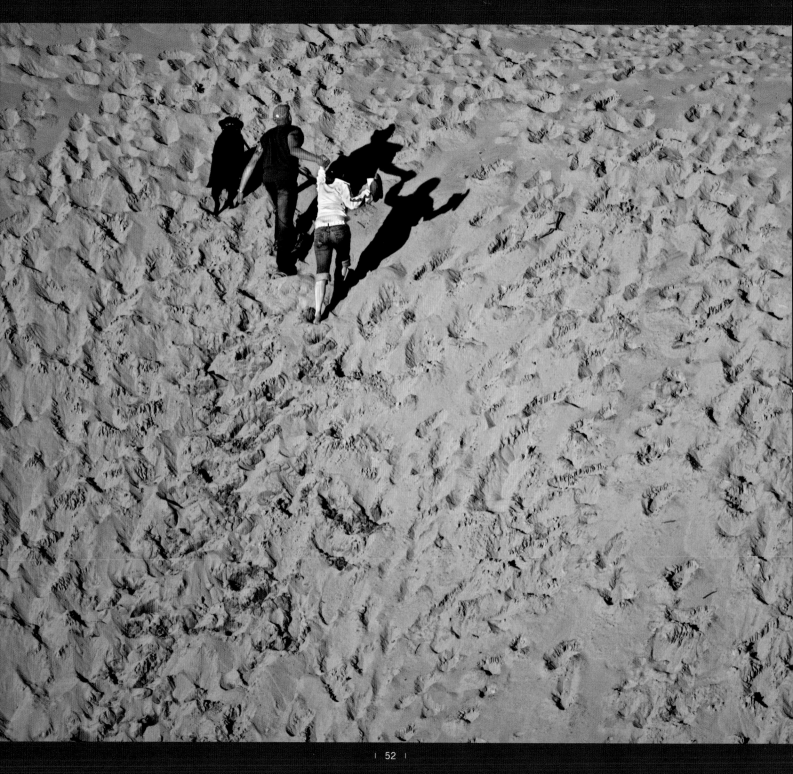

Left: Four legs are better than two for climbing this steep sand dune at Cape Kiwanda, prior to running and jumping all the way back down. The warm sand creates good updrafts, so the area is also popular with hang gliders.

Below: A rustic fence guides visitors to the ocean at Yachats State Recreation Area, for whale watching, gazing in tide pools, and fishing for rockfish and salmon.

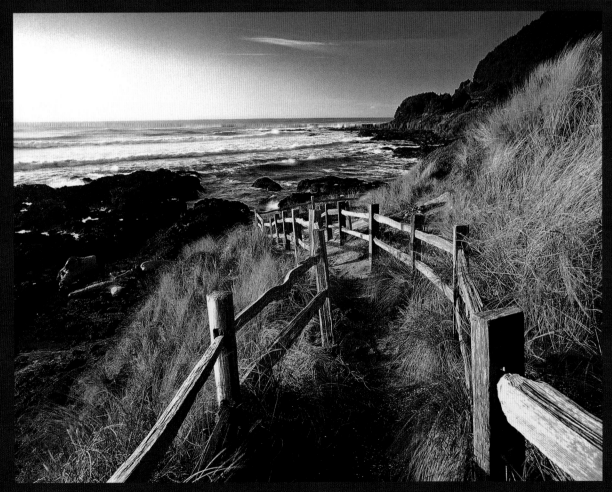

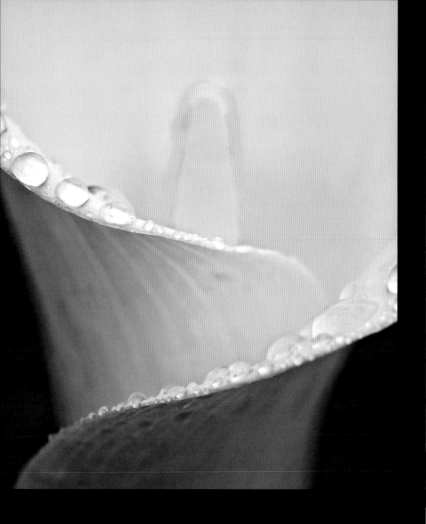

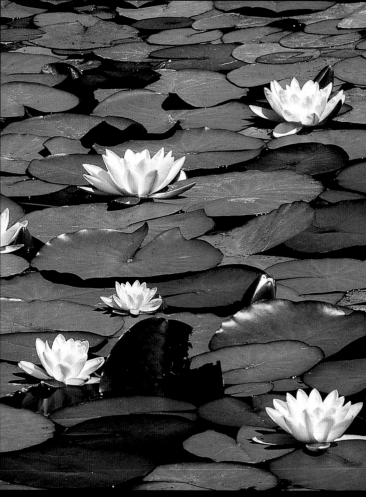

Above, left: A calla lily delicately holds the raindrops Oregon is famous for. The wettest months on the coast tend to be November through March, with up to thirteen inches of precipitation a month; July and August are quite dry, with less than two inches of rain falling each month.

Above, right: Water lilies bloom on a tranquil pond near Florence.

Facing page: Today only the intricate, luxurious gardens remain from the elaborate private summer estate built by pioneer lumberman/shipbuilder Louis J. Simpson. The estate is now part of Shore Acres State Park. Seen here, some of the 250 varieties of dahlias are in full glory.

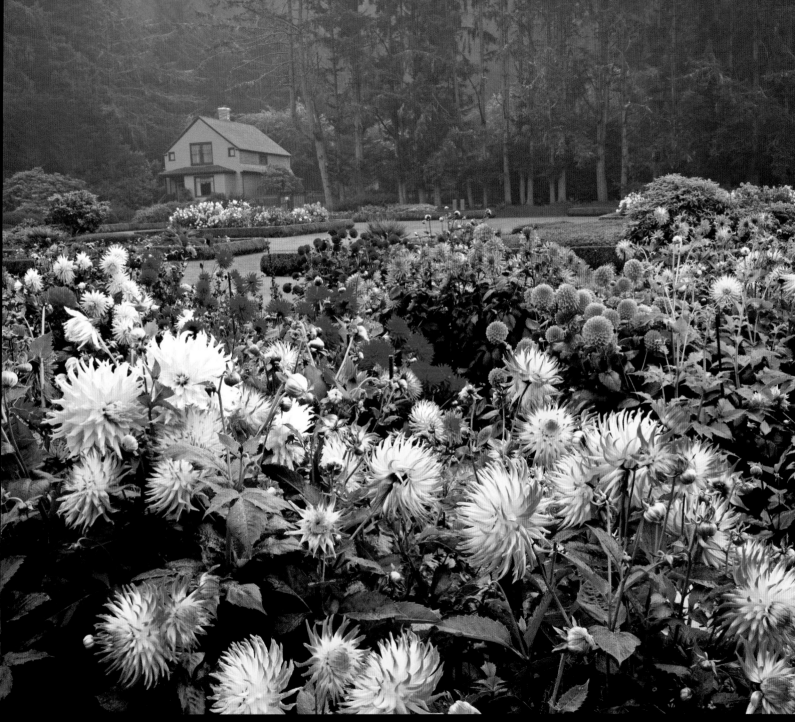

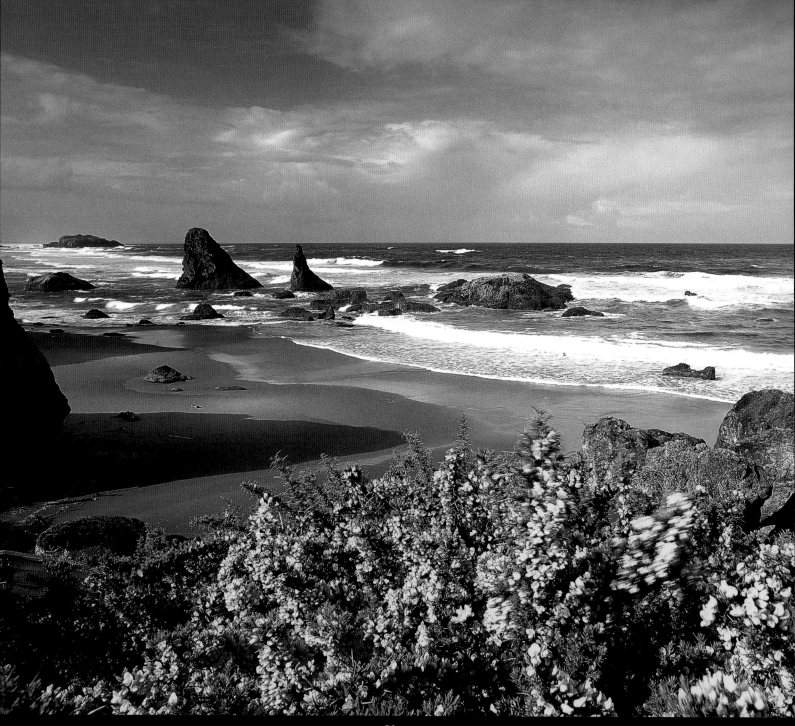

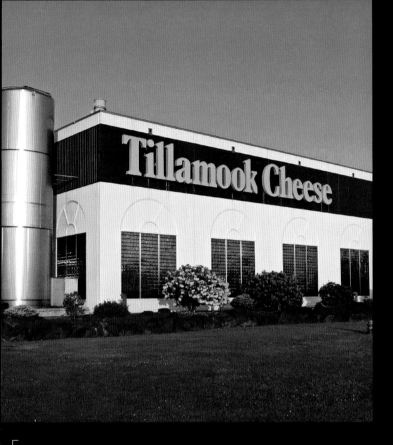

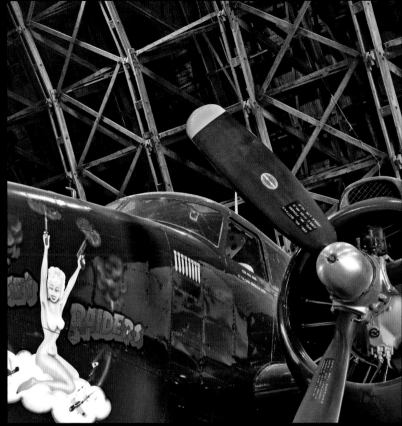

Above, left: The Tillamook Cheese factory, a cooperative owned by about 130 dairy families, has been churning out remarkably fine cheeses for nearly a century.
PHOTO COURTESY OF TILLAMOOK COUNTY CREAMERY ASSOCIATION.

Above, right: The pilot of this Lockheed PV-2 Harpoon customized the paint job in accordance with acceptable conventions of the WWII era. The aircraft is displayed at Tillamook Air Museum, which is housed in a hangar built in 1943 for U.S. Navy blimps. The wooden structure covers more than seven acres; its thirty-ton, 120-foot-high door sections roll open on railroad tracks.

Facing page: Wildflowers bloom along the coastline near Bandon.

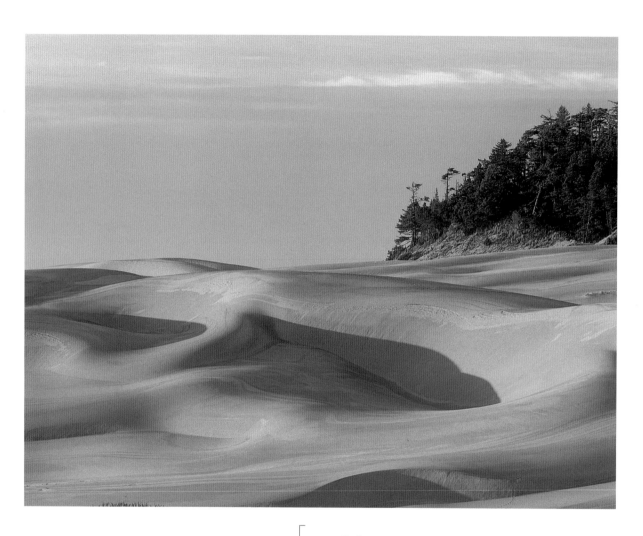

Above: Shadows created by the setting sun heighten the dramatic contours of the sand dunes at Oregon Dunes National Recreation Area.

Right: Seal Rock State Wayside provides access to view seals, of course, as well as sea lions and various sea birds that inhabit the offshore rock formations. Peak times for coastal bird watching are in April, when birds are migrating to Arctic breeding grounds, and October, when they return to warmer southern climates.

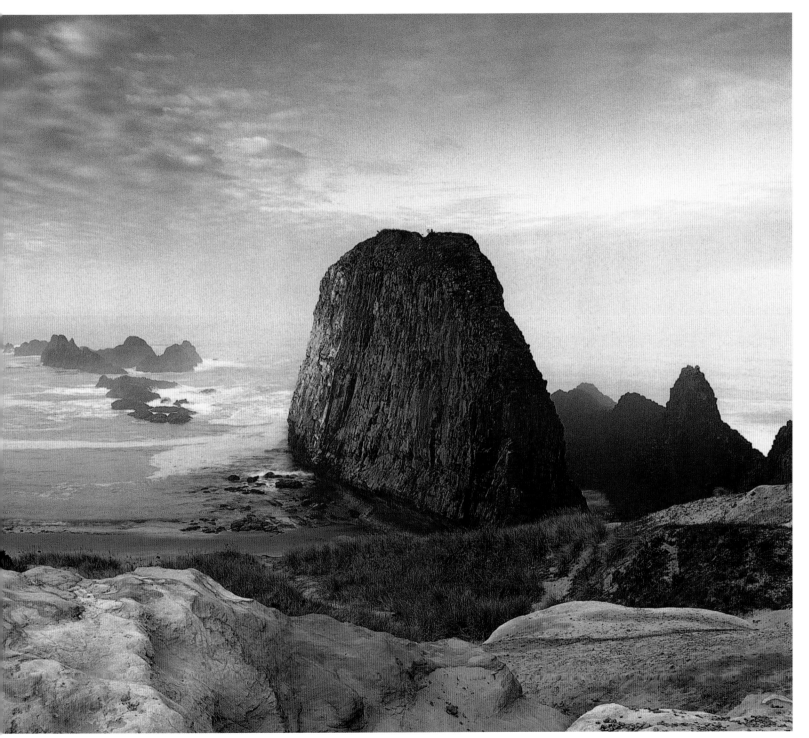

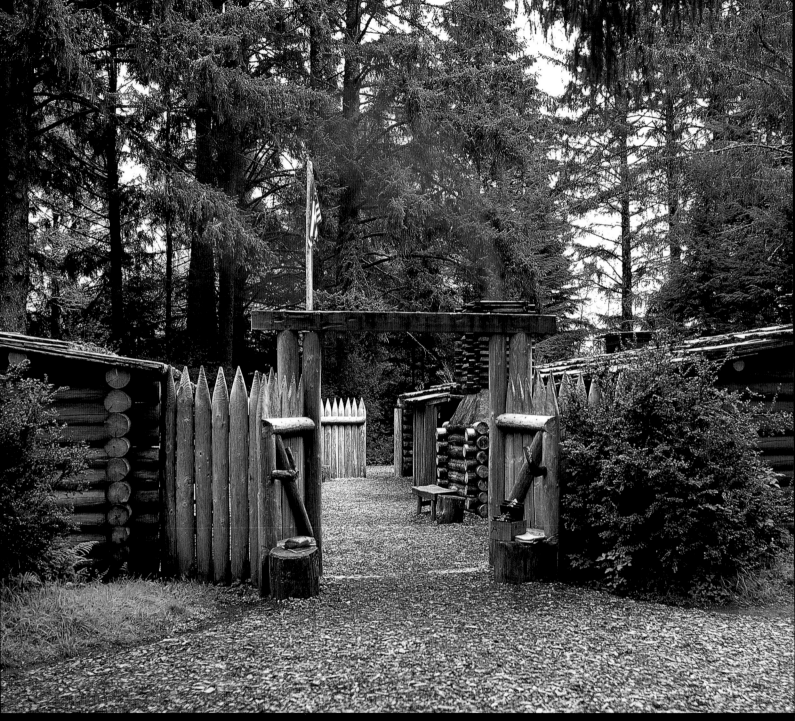

Left: Fort Clatsop replicates the encampment built by the Lewis and Clark Expedition, who wintered here in 1805–06. Visitors can attend ranger-led programs, see reenactments, and stroll along several hiking trails in the area.

Below, left: A reenactor at Fort Clatsop demonstrates how to fire a musket.

Below, right: A peacock shows his finest display in an effort to attract a peahen, at West Coast Game Park.

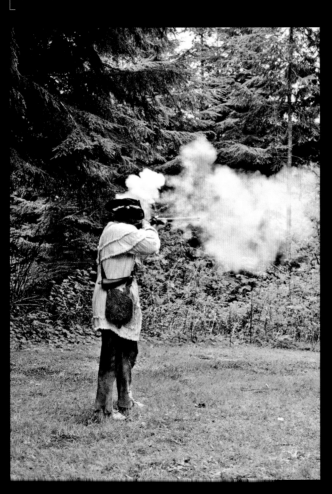

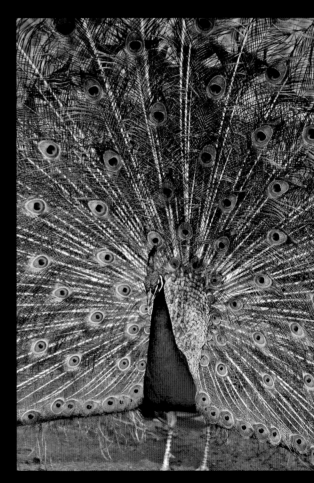

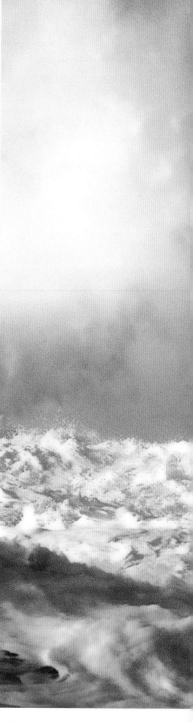

Right: A seagull seems to be enjoying its view of thundering surf and roiling seas during a storm at Devil's Churn.

Below: A gray whale calf rests its massive chin on its mother's even more gigantic snout. Grays are easily spotted from shore during their annual migration between birthing areas in Baja California, Mexico, and the rich feeding waters in Alaska's Bering and Chukchi seas. PHOTO BY BRANDON COLE

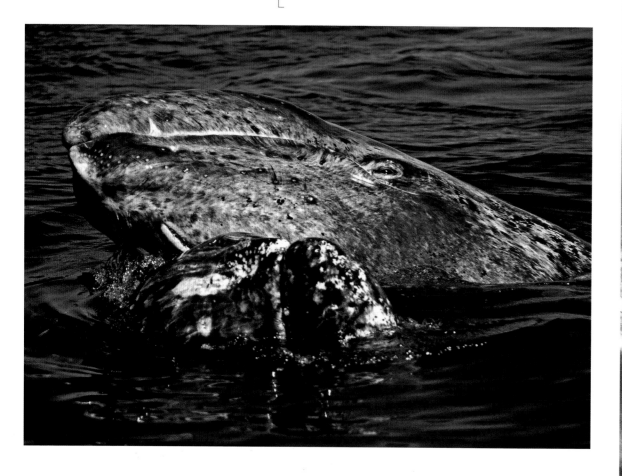

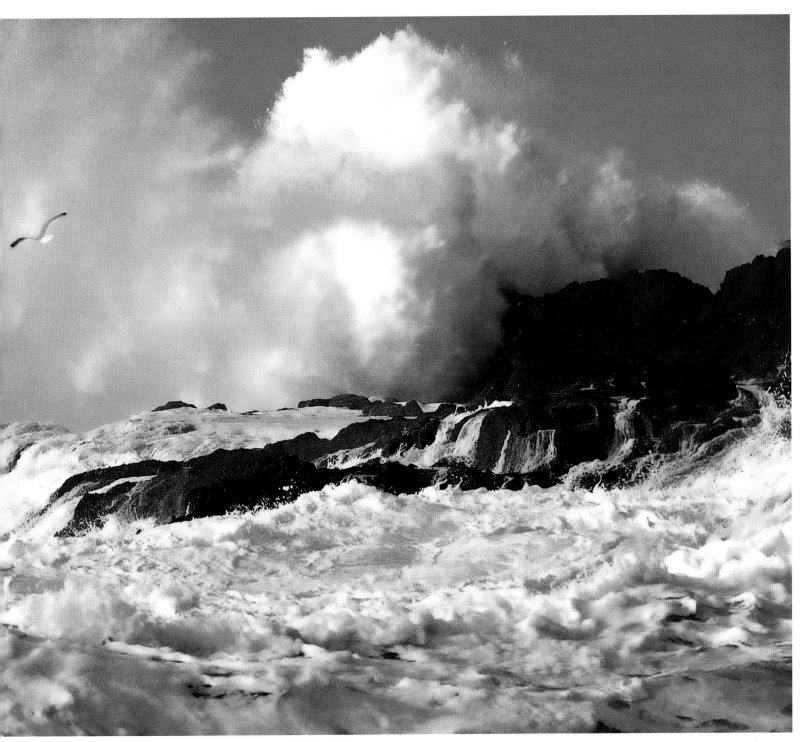

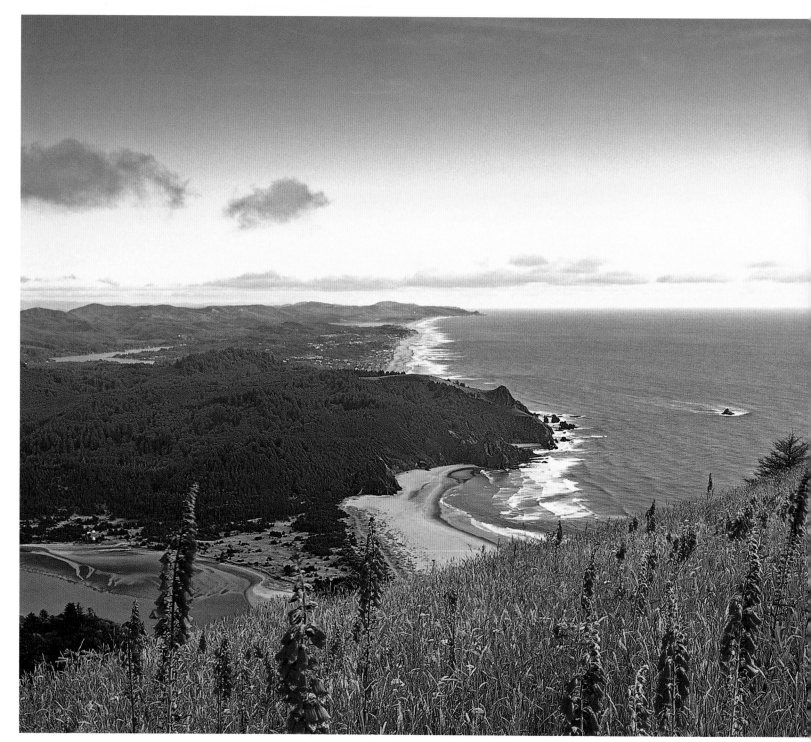

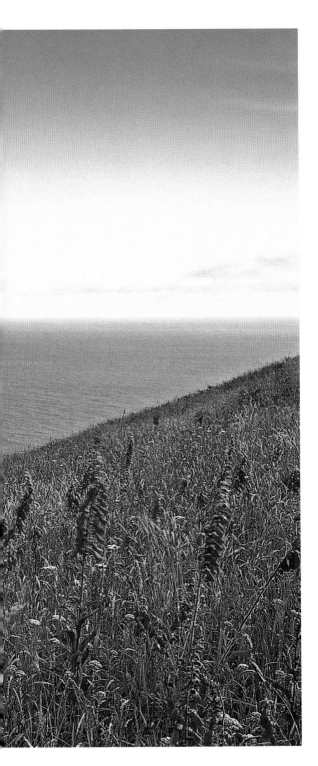

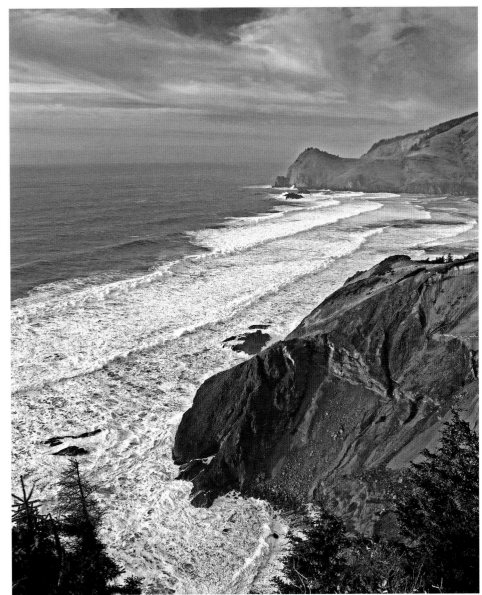

Above: Diamond-shaped Cascade Head protrudes into the sea. The Nature Conservancy's Cascade Head Preserve shelters so much diversity and so many rare species that it was declared a United Nations Biosphere Reserve.

Left: The magenta spires of blooming foxgloves spring up out of the grasses growing atop Cascade Head. The area is a refuge for the Oregon silverspot butterfly, rare plants, and grassland ecosystems that were formerly abundant along the coast.

Fishing rods and assorted boating paraphernalia create interesting reflections in the water around a commercial sport fishing boat moored in the Garibaldi boat harbor.

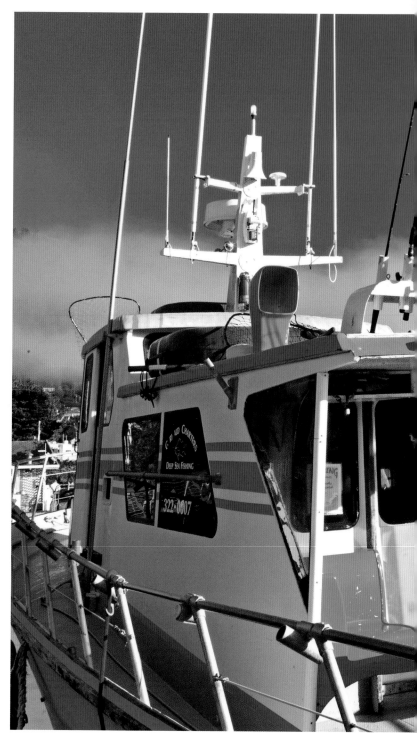

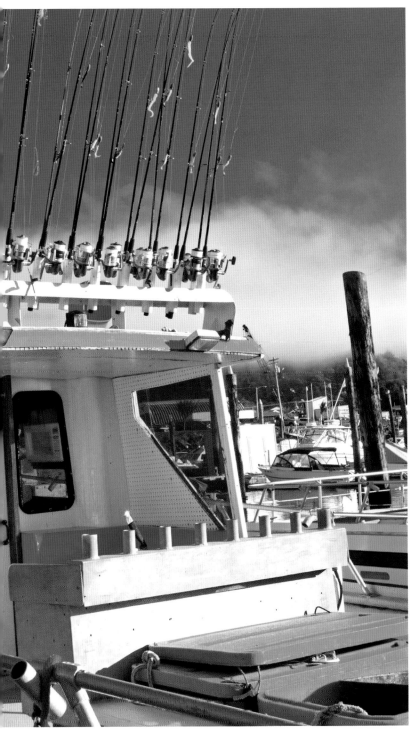

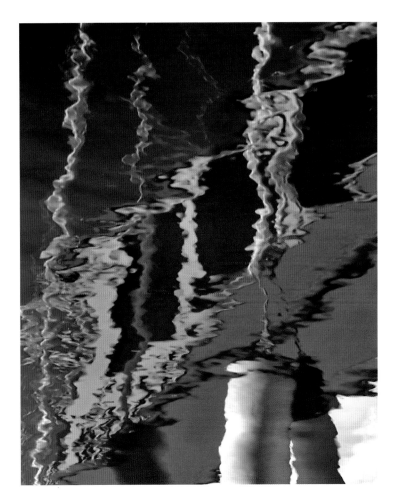

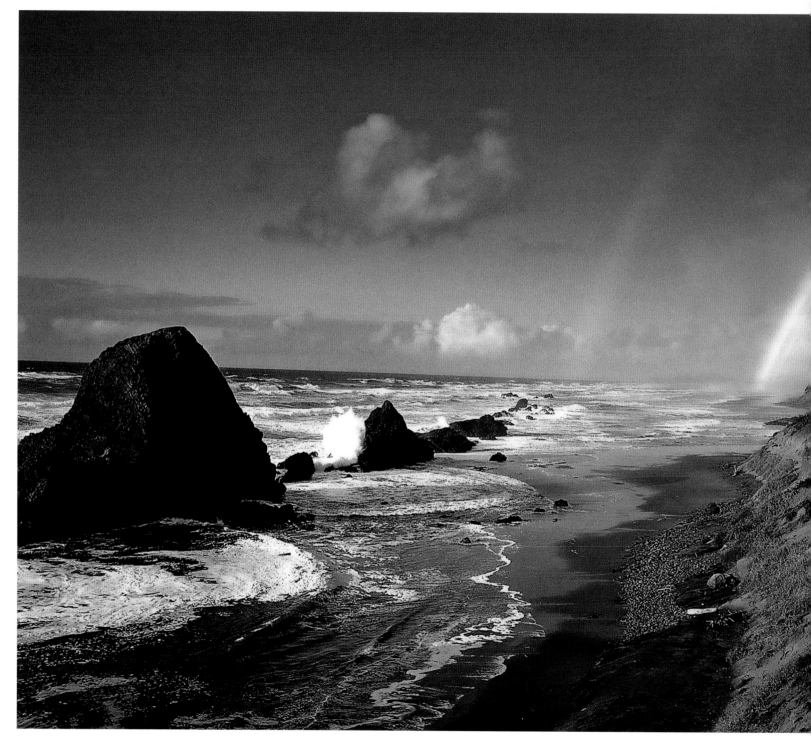

Left: Put on your clamdiggers to search for the pot of gold at the end of this rainbow near Seal Rock.

Below: A close-up view shows the intricate engineering of the reflectors that send the warning light out to sea from Cape Blanco Lighthouse. This was Oregon's first lighthouse to install a Fresnel lens; its lens and prisms amplified the light so efficiently it could throw a beam twenty or more miles.

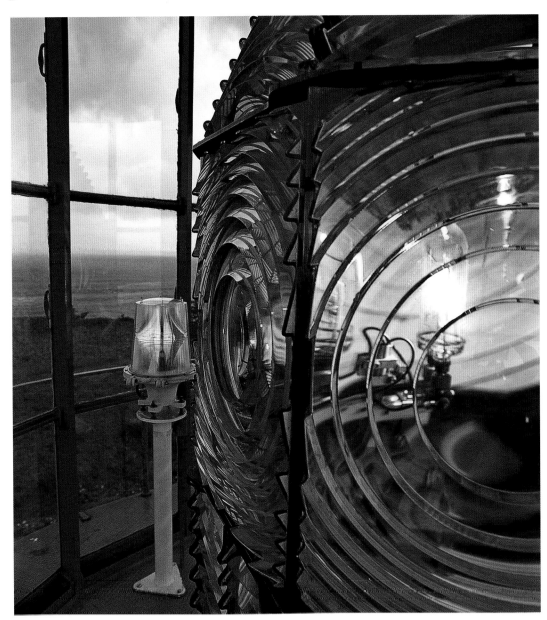

Right: Twenty-six miles of the Oregon Coast Trail wind through Samuel H. Board-man State Park, climbing up and down between viewpoints, such as this smooth, sandy bottom revealed by low tide.

Below: A dramatic thunderstorm unleashes its energy over the Pacific Ocean. Winter is the wettest season along the coast; pounding storms can last for days.

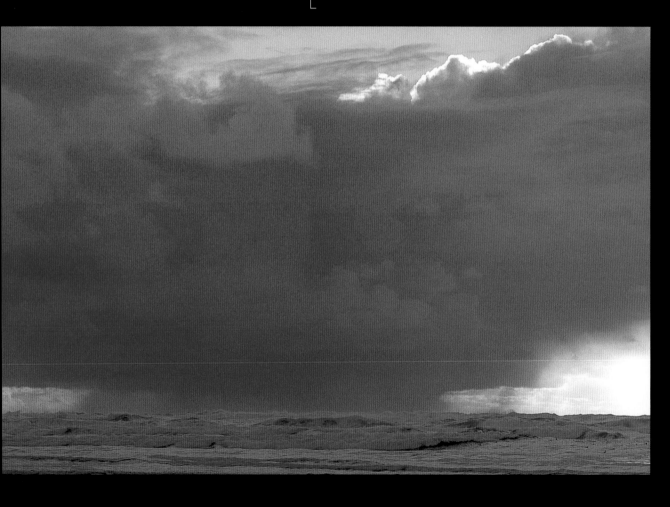

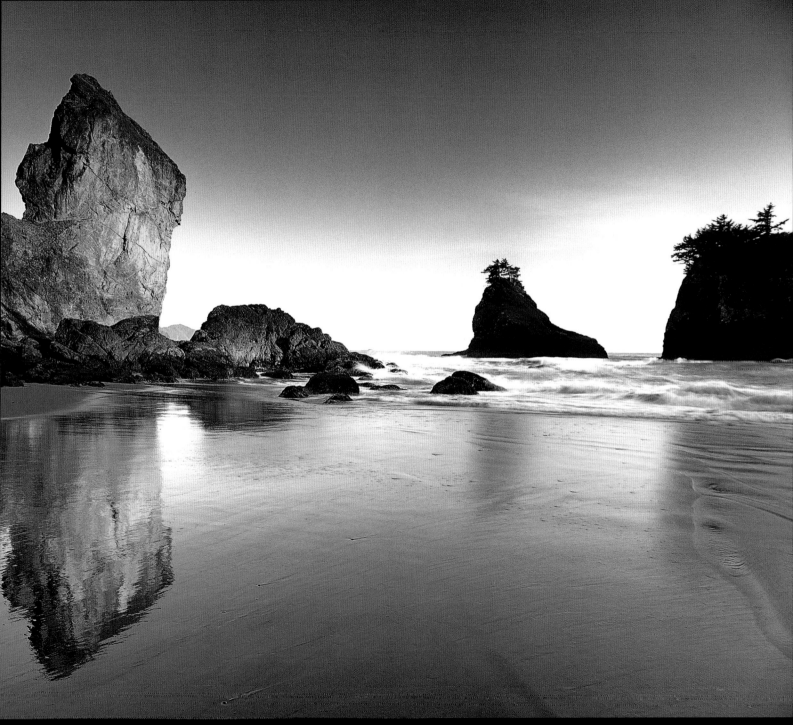

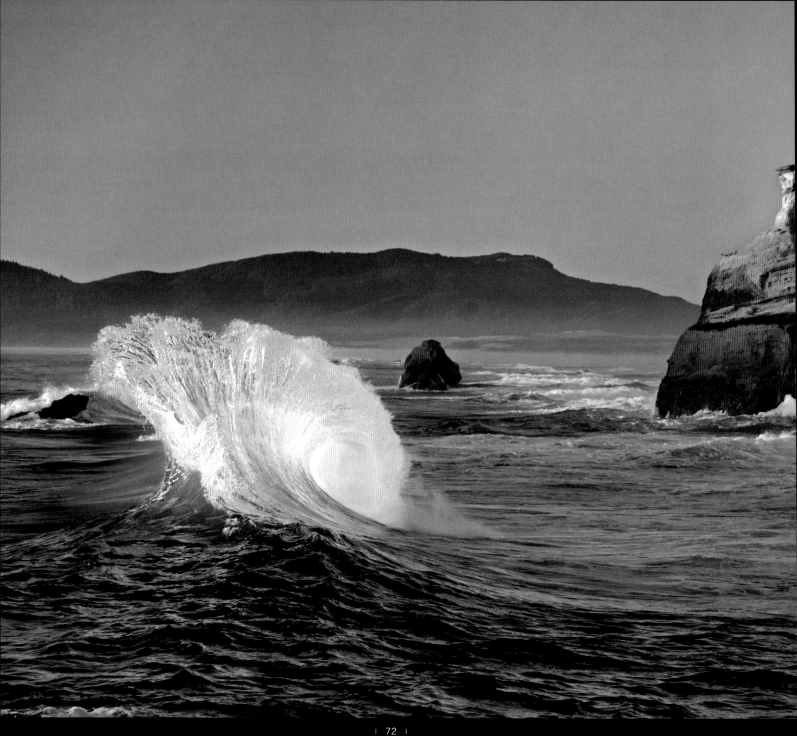

Left: Sunlight catches the sea-green color of ocean spray at Cape Kiwanda.

Below: One last ray of sunshine illuminates waves rocketing into the beach under a stormy sky near Tillamook Rock Lighthouse.

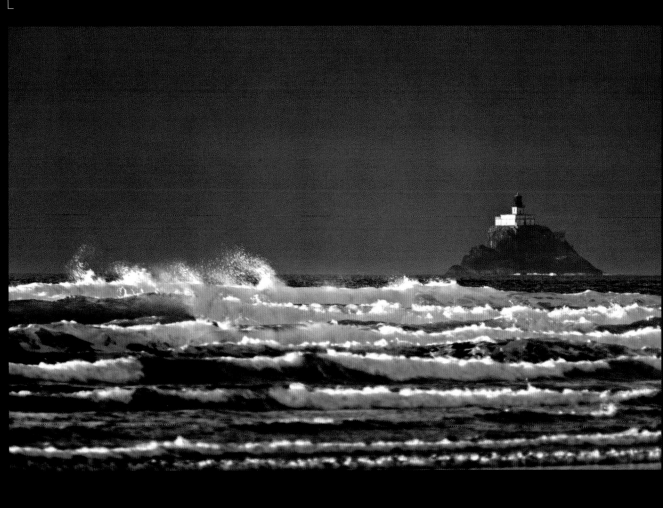

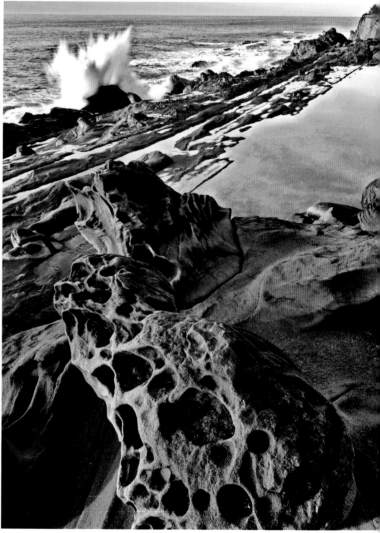

Above, left: Teenagers find plenty of ways to expend energy on a beach near Yachats. For more structured recreation, Yachats-area naturalists lead Tidepool Discovery Days throughout the summer.

Above, right: Rain, wind, and surf have pocked the rocks at Shore Acres State Park.

Facing page: Now little more than a curious relic on the beach, in 1906 the British vessel *Peter Iredale* sailed from Salina Cruz, Mexico, bound for Portland. Heavy fog and rain hid the lighthouse beacons, and the vessel ran aground. All twenty-seven people aboard were rescued.

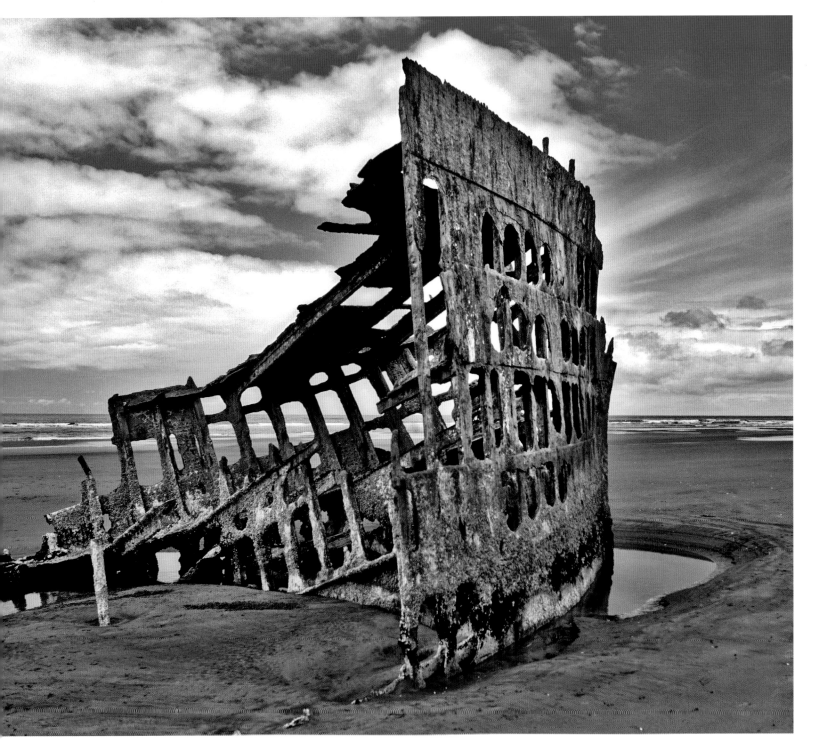

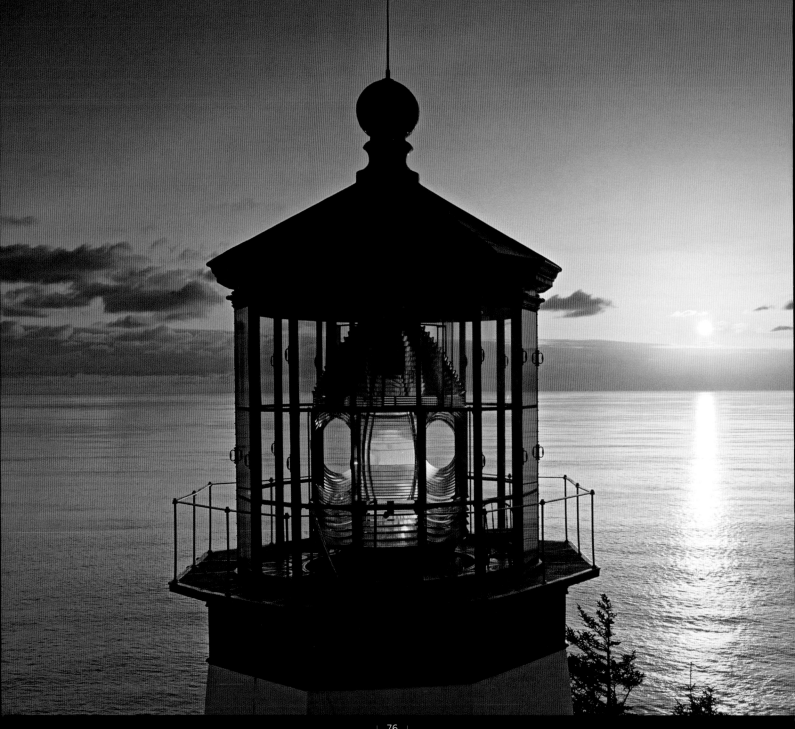

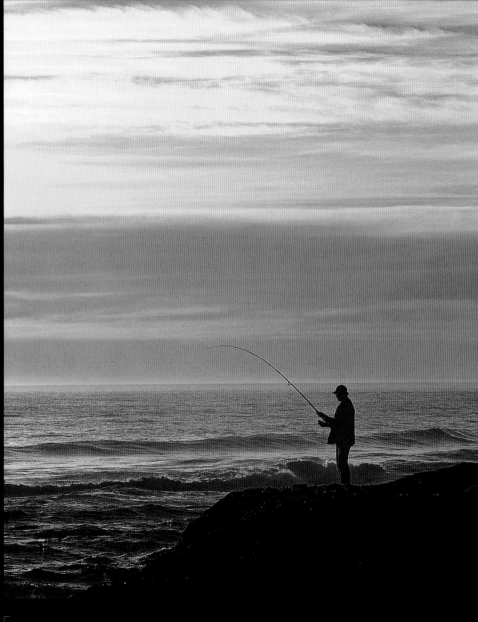

Above: With this kind of scenery found from the rocky shore at Cape Perpetua, it hardly matters if you catch a fish.

Left: The beacon from the 1890s Cape Meares Lighthouse will warn sailors of navigational hazards once the sun drops below the horizon. In spring, the surrounding State Scenic Viewpoint provides a vista of Oregon's largest colony of nesting common murres.

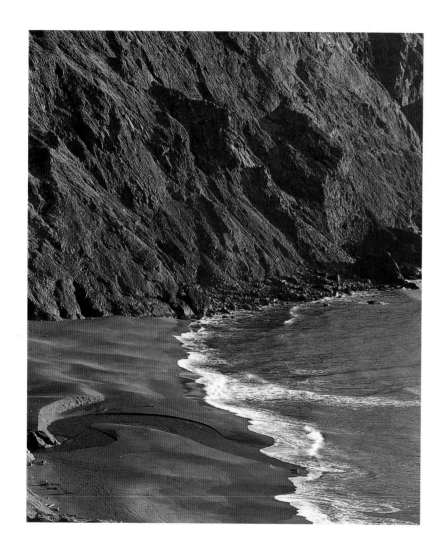

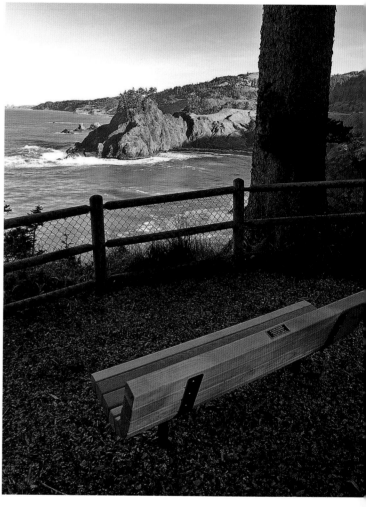

Above, left: Brush Creek adds its humble volume of water to the ocean at Humbug Mountain State Park.

Above, right: Hikers on the 362-mile-long Oregon Coast Trail can rest here and enjoy the inviting scene from Arch Rock Viewpoint. This overlook/picnic area along Highway 101 is in the Samuel H. Boardman State Scenic Corridor.

Facing page: The wildly churning surf pounds the cliffs, captured in a time-lapse photo at Devil's Punch Bowl State Natural Area.

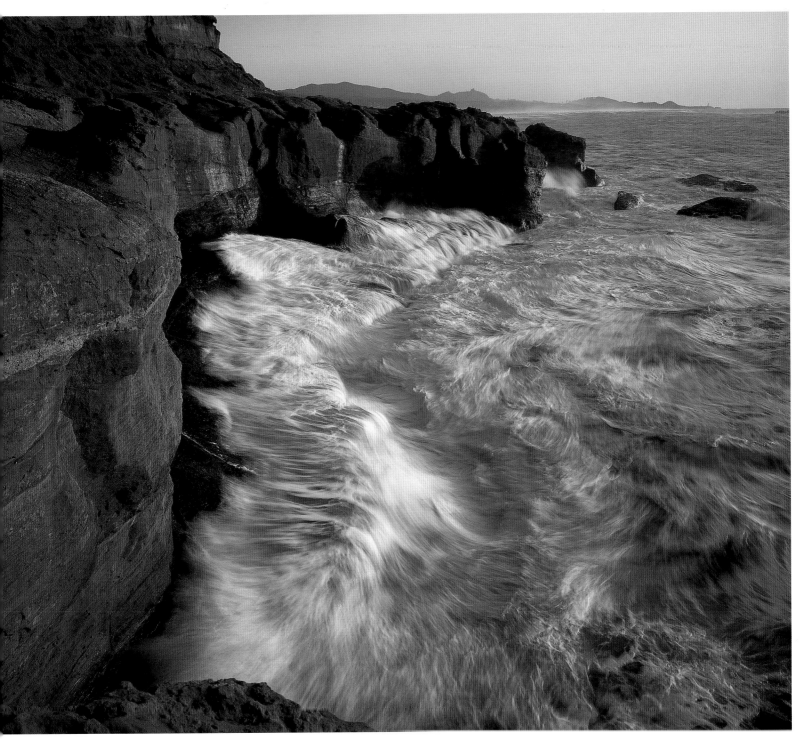

Dennis Frates earned degrees in physical geography and ecology before turning his attention to photography. For most of the past quarter century he has produced 10,000 to 15,000 photographs a year with his medium and large format film cameras and, more recently, a digital camera.

His work continues to be selected for national juried exhibitions. He has won numerous awards, including the prestigious Westmorland Art Nationals "Photograph of the Year."

Dennis hikes in all seasons along the coast, as well as through western forests and into the desert. His photographs have graced the pages of *National Geographic*, *Sierra*, and *Audubon*. His books include *Discovering Joy*, *The Ideals Treasury of Faith and Inspiration*, and *The Ideals Treasury of Hope*, as well as Farcountry Press's *Oregon Wild and Beautiful*. Eighteen wall calendars showcase his exceptional nature images exclusively.

Dennis's primary passion today is for his fine art prints; a collection of them will be featured in his next book entitled *Lightdances Across the Landscape*.

Learn more about his work at www.fratesphoto.com.

Right: A sophisticated, multi-level kite awaits the perfect breeze to blow on the beach at Lincoln City.

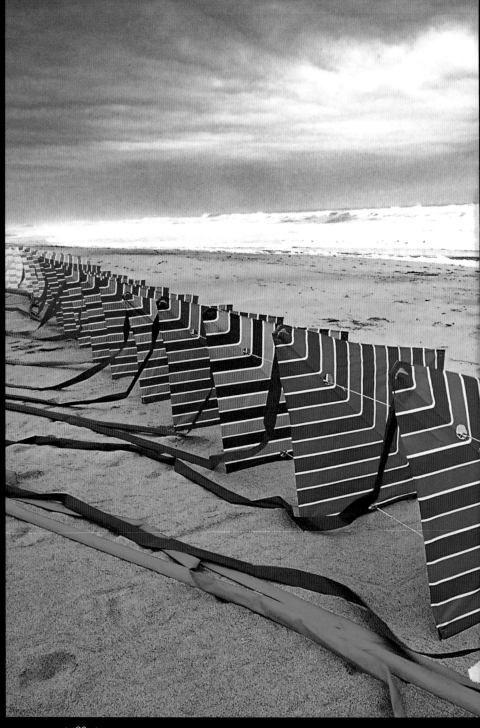